CU00810654

SHINE

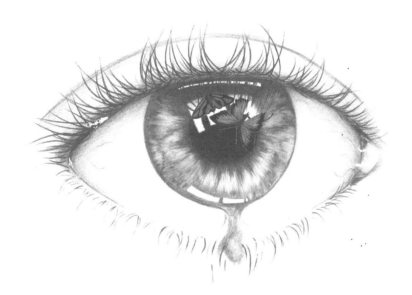

Poetry by Skylar J Wynter Artwork by Neshka Turner

Dragonfly Publishing

Copyright

Cover artwork: Neshka Turner

Dedication

For three young men I am blessed to call my sons.

The first, without whom my education in philosophy would be sadly lacking, the second, a *loose goose* whose childhood antics and irreverent sense of humour kept me on my toes and taught me the art of 'just smile and wave', and the third, a perfect blend of adorable and rascal, who taught me miracles are irrefutable. Thank you.

For the young woman I am blessed to call my daughter. I taught you that laughing on a rollercoaster tricks your brain into not being scared. You worked out life is a rollercoaster and are brave beyond your years, so now it is you teaching me. Thank you.

And, for the middle-aged Boomer White guy I am blessed to call my best friend. You have taught me love and respect can exist between people who don't see life through the same lens and it has been the greatest of gifts. Thank you.

SKYLAR JOYNTER

For everyone who touched my life; be it with a smile, a word, time spent together recently or 40 years ago. You all matter. Every single one of you had an impact on where I am now, positive or other. Thank you.

MESHKA TURNER

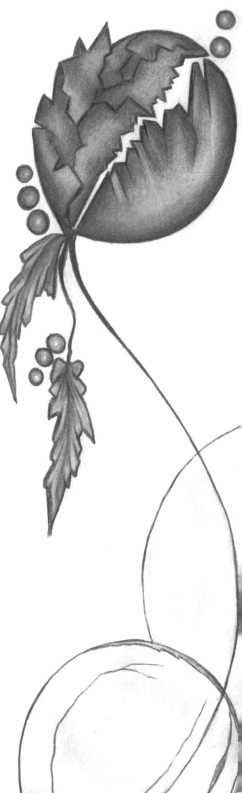

ℱOREWORD

We are all blessed with 'sliding door' moments in our lives and I say blessed because it is usually these moments that help us redirect, redefine, reassess ourselves and our life's trajectory.

Mine was an incident in 2014 in a random carpark with a random stranger and their car. What ensued was a plethora of exquisitely painful, unquestioningly eye-opening moments that stretched out over the years between then and now. Moments that brought me heartache and joy, hope followed by abject hopelessness, new friends, new voices, new opinions, new questions, new answers; basically, a completely new way of being and I am striving to get comfortable with it.

My first book, *Pieces of Humanity*, was filled with gritty, hard-hitting stories and poetry asking the question: what lies beneath the surface? and proposing that whilst we are ultimately alone in the experience of our own internal landscape, once we recognise and validate that everyone is in the same boat, we create room for validation and compassion which can bring us the connection we all desire.

The poetry in this book is no less brutal and at times incorporates language that is confronting and unpleasant, to say the least. I do not use words flippantly or with disregard for the readers sensibilities. In fact, I would say I am slightly obsessive about choosing exactly the words I want to use in exactly the right place to convey exactly what my experience is. I prefer to be in a relationship with living things, but when it comes to inanimate objects, I openly admit I have a very strong attachment to my Thesaurus, and I do not consider my work fit for human consumption until I reach the moment when all the words are just as they should be to convey *my* experience (my personal truth) or *my* interpretation (my opinion, not fact) of an experience.

So, if you come across poems or words within poems that trigger discomfort, disgust, judgement, disbelief, a raised eyebrow, a laugh, a question, please know that my intent was to convey the strong emotions felt by me or the pervading questions I ask myself around these topics. It is my intention to express my internal reality as succinctly and powerfully as possible in the hopes of creating space for conversations where I and others can be respectfully educated.

I am human. Perfectly flawed. I try to start each day remembering I know nothing, thus leaving room to be taught something. I am not attached to my opinions and openly welcome any opportunity for someone to show me another facet or perspective. All of us have been shaped by our inherited beliefs and traumas, our lived experience and our personal perspective on our lived experience—we cannot know what we do not know, but we can choose to treat ourselves and others decently from the perspective of that realisation. And in doing so, we are creating space for ourselves and others to SHINE.

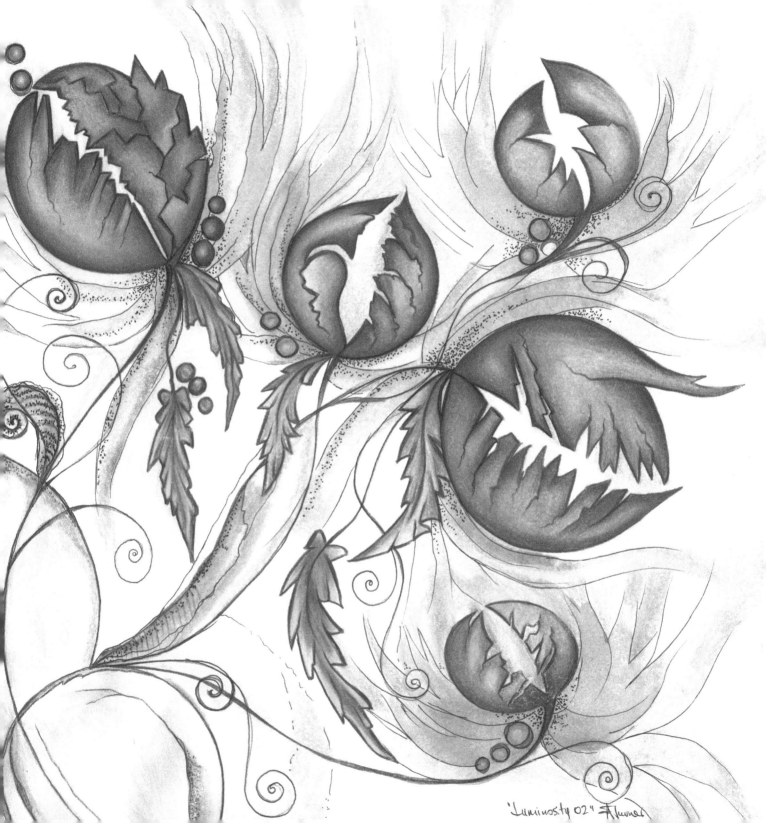

'Luminosity 02' S Turner

PART 1

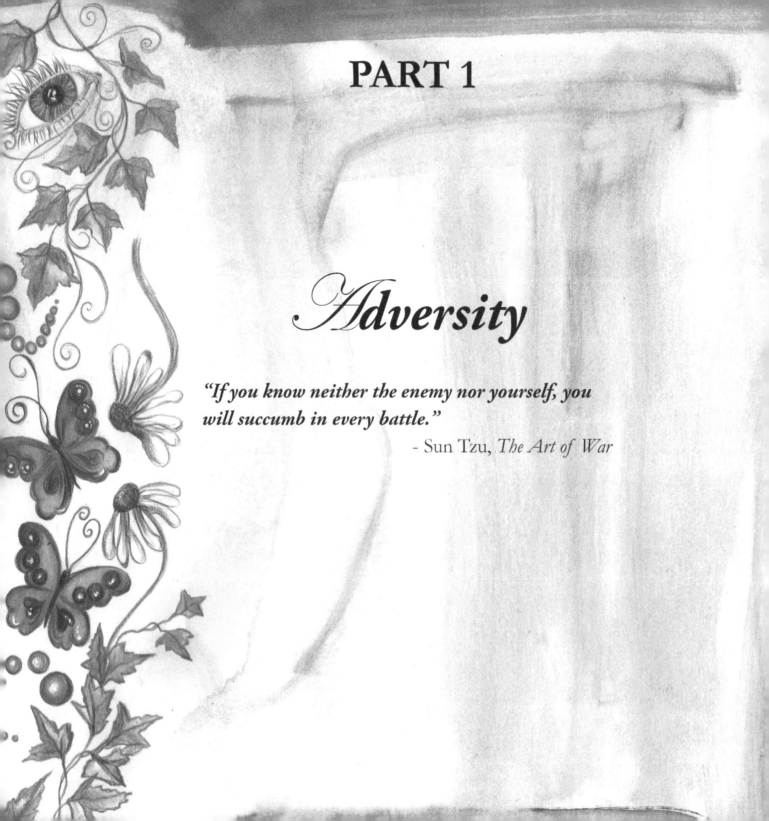

Adversity

"If you know neither the enemy nor yourself, you will succumb in every battle."

- Sun Tzu, *The Art of War*

CONTENTS

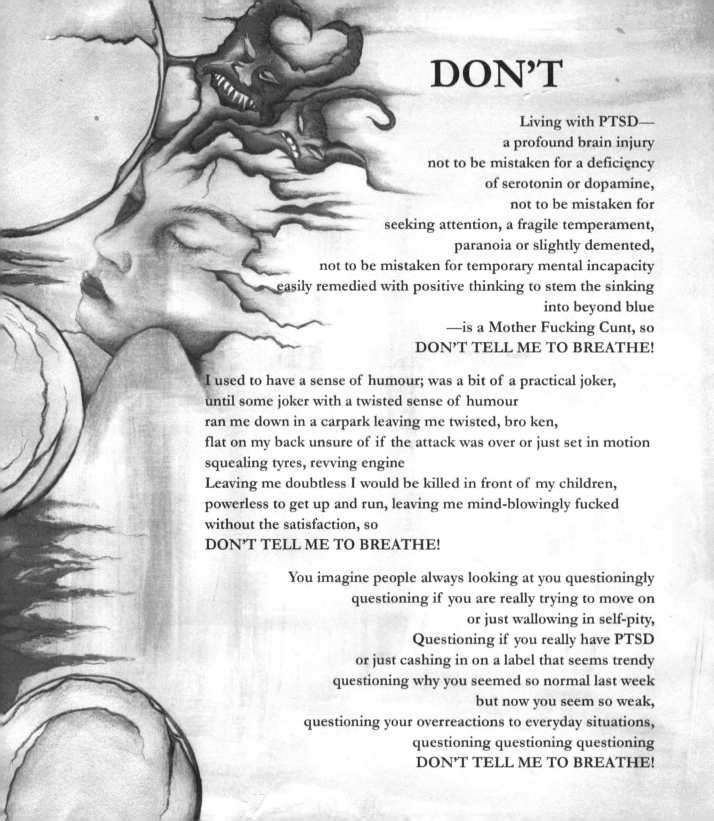

DON'T

Living with PTSD—
a profound brain injury
not to be mistaken for a deficiency
of serotonin or dopamine,
not to be mistaken for
seeking attention, a fragile temperament,
paranoia or slightly demented,
not to be mistaken for temporary mental incapacity
easily remedied with positive thinking to stem the sinking
into beyond blue
—is a Mother Fucking Cunt, so
DON'T TELL ME TO BREATHE!

I used to have a sense of humour; was a bit of a practical joker,
until some joker with a twisted sense of humour
ran me down in a carpark leaving me twisted, bro ken,
flat on my back unsure of if the attack was over or just set in motion
squealing tyres, revving engine
Leaving me doubtless I would be killed in front of my children,
powerless to get up and run, leaving me mind-blowingly fucked
without the satisfaction, so
DON'T TELL ME TO BREATHE!

You imagine people always looking at you questioningly
questioning if you are really trying to move on
or just wallowing in self-pity,
Questioning if you really have PTSD
or just cashing in on a label that seems trendy
questioning why you seemed so normal last week
but now you seem so weak,
questioning your overreactions to everyday situations,
questioning questioning questioning
DON'T TELL ME TO BREATHE!

TELL ME TO BREATHE

Trauma physically changes the brains neurobiology.
Neural pathways directing memories to be parked
in the underground carpark of the past–have been bypassed
so, if you startle me, behave unpredictably, make me feel uneasy
it's like déjà vu and boom!
I freefall without the bungy cord into adrenal system overload,
my brain tries to instill reason
screaming all the reasons why this is not the same thing
as THAT thing, as THAT thing, as THAT thing, so
DON'T TELL ME TO BREATHE!

It will not reconnect the disconnect between mind and body,
deactivate my overactive amygdala
trigger my prefrontal cortex to behave as an emotional regulator
create an exit route for memories off the hippocampus roundabout
so my brain can figure out the difference between past trauma
and the here and now
so it can figure out, your joking about is nothing to freak out about, so
DON'T TELL ME TO BREATHE!

Hug me, without judgement, as I cry it out.
Soothe me as you would a child.
Accepting this new version of me,
is the only way to grant my hell any kind of validity.
Don't think that because the brain is elastic it can heal this injury,
don't think I haven't tried every available treatment already,
don't shame or mock or pity me
and DON'T fucking tell me
to breathe.

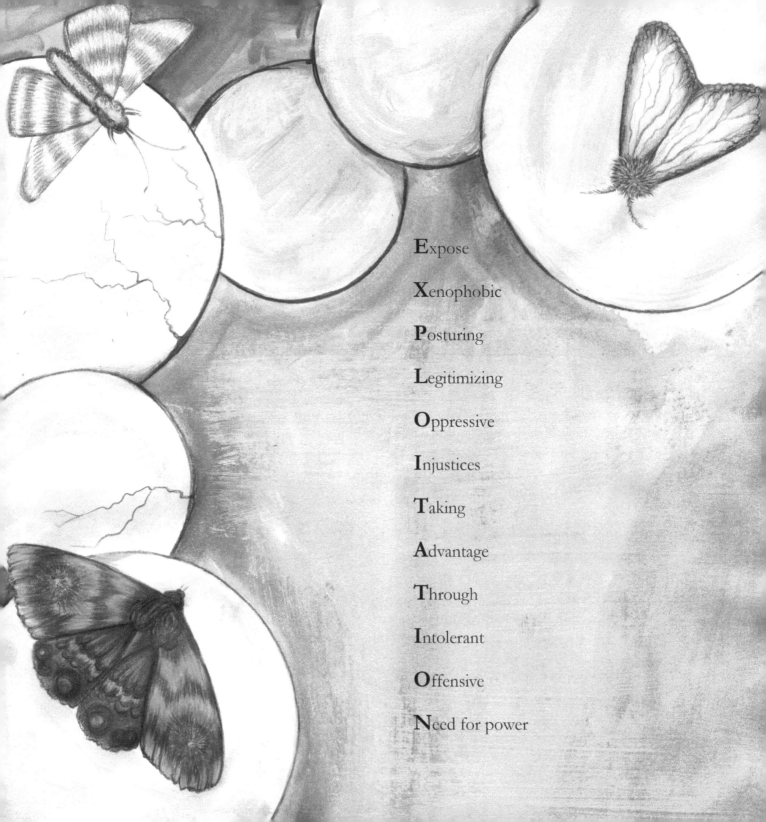

Expose

Xenophobic

Posturing

Legitimizing

Oppressive

Injustices

Taking

Advantage

Through

Intolerant

Offensive

Need for power

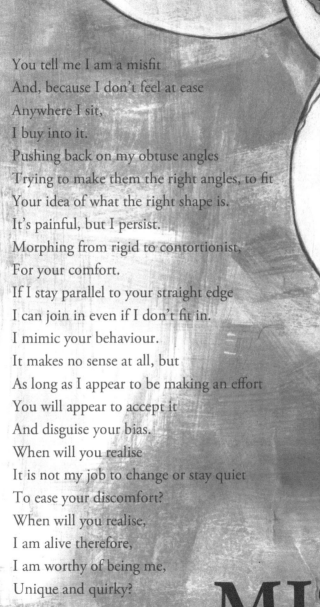

You tell me I am a misfit
And, because I don't feel at ease
Anywhere I sit,
I buy into it.
Pushing back on my obtuse angles
Trying to make them the right angles, to fit
Your idea of what the right shape is.
It's painful, but I persist.
Morphing from rigid to contortionist,
For your comfort.
If I stay parallel to your straight edge
I can join in even if I don't fit in.
I mimic your behaviour.
It makes no sense at all, but
As long as I appear to be making an effort
You will appear to accept it
And disguise your bias.
When will you realise
It is not my job to change or stay quiet
To ease your discomfort?
When will you realise,
I am alive therefore,
I am worthy of being me,
Unique and quirky?

MISFIT

DID YOU EVER ASK?

If I kept bringing you glasses of water to quench a thirst that did not exist,
how long do you think it would take before you felt well and truly pissed?
How long do you think it would take before you felt you needed to insist
that water wouldn't fix the anguish, of your real needs being dismissed?

Your reward for *helping* is your ego preening, chest filled with righteous wellbeing
regardless of whether the help you deliver is what I need.
You are failing to do the one thing that would make you truly deserving
of those accolades you are secretly yearning.

You are failing to take an interest in what would truly make a difference.
Failing to recognise the common label to my being otherwise abled,
does not mean the help that I need to achieve at the level I am able,
is the same as other individuals pegged with the same label.

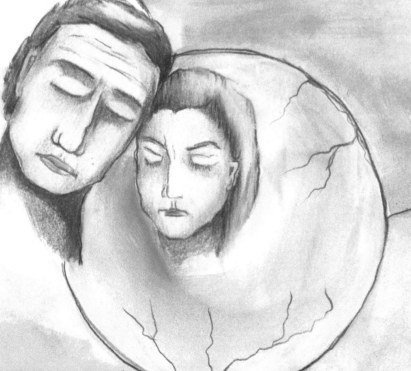

I am boxed within a paradox
created by a form, formed upon the ideation
that only those, Low Functioning, require any kind of helping.

Have you ever considered looking into the cracks so many of us fall through
and asking if the millions you spend advertising what you do, could be used to
hire a multitude of real people asking questions to ensure any help funded by you,
was applicable to those weaving through an obstacle course they didn't choose?
A course in navigation through subjugation of a darkness you won't look into,
yet want us to climb out of with a non-negotiable slide you insist we use
when an adjustable ladder would be a more appropriate tool.

We wouldn't be the drain on society you think us to be,
if we had access to help specific to us individually.
Our desire to work, live, exist, independently,
aligns itself precisely with how you want us to be.
Those of us High Functioning can shop, drive, dress, wash,
read a map, catch a bus, do what is neurotypical, pretty much.
But our brains, wired somewhat uniquely,
make social niceties non-sensical and difficult.

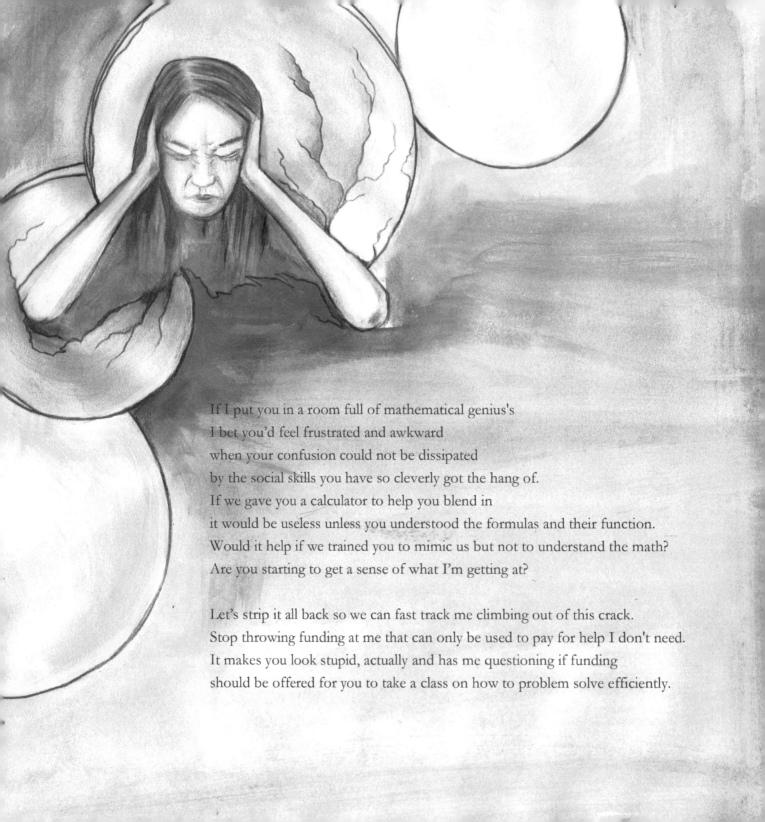

If I put you in a room full of mathematical genius's
I bet you'd feel frustrated and awkward
when your confusion could not be dissipated
by the social skills you have so cleverly got the hang of.
If we gave you a calculator to help you blend in
it would be useless unless you understood the formulas and their function.
Would it help if we trained you to mimic us but not to understand the math?
Are you starting to get a sense of what I'm getting at?

Let's strip it all back so we can fast track me climbing out of this crack.
Stop throwing funding at me that can only be used to pay for help I don't need.
It makes you look stupid, actually and has me questioning if funding
should be offered for you to take a class on how to problem solve efficiently.

NO! WAIT!

Here's a funding requirement no-one's willing to renunciate–

To extend your education, you cannot use your funding.

You can use it to pay a person, with no interest in learning,

(Job description: Carer. Purpose: nothing, because you are High Functioning),

to sit next to you in class.

THAT'S RIGHT!

funding to be babysat when your needs do not require that,

but nothing for upskilling so you can become a willing

participant in a society you want to be included in.

If you thought to ask me what real help would look like

I could tell you exactly and far more efficiently than me

checking sixty-two pages of boxes that lead to you shrugging and saying

there is nothing you can do, except offer me funding I can't use.

If you asked me, I could tell you what I need to prevent me

falling between the cracks you refuse to perceive.

I could live a life that likely would ensure otherwise abled you,

To live a life much better too, because I excel at things you can't understand or do.

But statistically, I'm not likely to get a shot at any meaningful task,

because the powers that be, never think to ask.

THE UNSEEN

Dirty. Homeless. A boy living on the street.
The street your feet are walking, at a frenzied frenetic speed.
A speed that propels you forward, eyes forward so they don't meet,
The blatancy of him on his dirty pavement seat.
Exiled to your periphery you pretend you do not see.
The ugly so obscene is evanesced into unseen.

Child. Unkempt. Wearing a jumper far too thin
To offer any protection from the bitter winter wind.
Holes in his shoes are letting the wet, on pavement, in
And from that odour of damp socks you cannot deny knowing.
Yet you exile him to your periphery, pretend you do not see.
The ugly so obscene is evanesced into unseen.

Why do we focus on blurring horrors we'd rather not see?
Why are we convinced we can't change much of anything?
Why do we accept the premise, ugly of magnitude too extreme,
Should be exiled to the periphery; evanesced into unseen?

How have we become so numb to the homeless, to the drugs?
To the poverty and the loneliness inhabiting human hubs?
How much more on the periphery will we pretend we cannot see
before the entirety of human experience
is evanesced into unseen?

DROPLETS

DROPLETS LAY ON CHEEKS

A REMINDER I STILL FEEL

EVEN THOUGH I'M NUMB.

UNREST

HEARTBEAT THUDS IN CHEST

SPEEDIER THAN REQUIRED

WHEN I'M AT REST

HOPE FATALITY

HOPE EVERLASTING

DISINTERGRATES IN PIECES

WITH DISINTEREST

IT COULD BE ME

Is it just me or, can everyone see
The management of this place
Is based in crazy?
I find myself questioning incessantly,
The long-term stability of a country
That has all it needs for self-sufficiency
Yet repeatedly supports the insanity
Of closing down manufacturing companies.
Companies, that if kept operational,
Would be the foundation of a marketplace sustainable
Not to mention profitable and indestructable
Not to mention reliable and credible

If *Management* is not invested in
Building a nation built on a bedrock of decency,
Of all citizens being treated decently,
Of ensuring a playing field of equality AND equity,
Of incubating a society unquestionably striving
To do more than just surviving,
Where are we headed really?
Why aren't we insisting, only items fully inciting
The abolition of all that's depriving us from mentally and physically thriving,
Be allowed to appear on any politically conniving
Agenda?

Let me rephrase the question because I may have confused you with
A thought that can't be referenced to research done meticulously
By teams of people paid by *The Company*.

What is going on when a country resourced to the hilt,
Allows them to be shipped full-tillt
Off shore—raw
Because for the sake of a dollar
We've shut down our value-adding infrastructure?
I mean what the actual fuck is the point of saving a buck
When we have a society chock full of human beings
Filled to full with suffering
'Cause they can't get off the hamster wheel
Of a madness that's gone global?
And no, I won't give you facts and figures
When it takes no brain to figure out
What's plain to see through eyes steeped in mediocracy.
No-one needs a degree to understand the degree
So many are suffering unnecessarily.
We know what we are living experientially.

So again, here is my question,
Is it just me,
Or is there some kind of fuckery
Going on with the management
Of this country?

ALGEBRA LESSON

Only Algebra Lesson 101
Can explain how difficult it is
To make letters of unknown quantity equal something positive.
They precede the names of my family like university degrees,
But the only doctorate we can claim is in dys-function-ality.
PTSD divided by ASD multiplied by ADHD to the power of three,
Means the probability of cascading catastrophe recurring
All too regularly - is most fucking likely.
ADHD leaps about in the equation causing fractionation
Within every conversation, triggering a PTSD supernova detonation
Emotional attachment is subtracted by ASD
Who manipulates logic into brackets and presents scientific facts on any given topic
Complete with referencing irrefutable leaving us speechless and bamboozled.

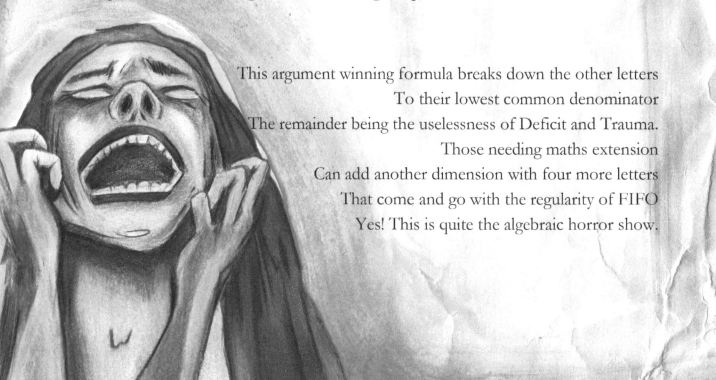

This argument winning formula breaks down the other letters
To their lowest common denominator
The remainder being the uselessness of Deficit and Trauma.
Those needing maths extension
Can add another dimension with four more letters
That come and go with the regularity of FIFO
Yes! This is quite the algebraic horror show.

The fallout fills our lives with a dark symphony of sounds that sound
Suspiciously like judgements disguised as suggestions - all profound
But no matter where you place the letters in this equation,
They will only ever equal Attention Deficit, Post-Traumatic Stress,
Fly In Fly Out, and Autism Spectrum–

Added to each other within the brackets of one family,
You get the sum-total of emotional fuck-upery
You get a mother morphing to monster, doing far more harm than good,
Becoming a mother becoming a monster, becoming a mother full of guilt.
Children becoming monsters whenever frustration starts to build.
Fathers, notwithstanding the shit storm that comes at them full tilt,
Becoming monsters filled to overload with overwhelm, but still
Having to make the best of things until they fly away again.
Mothers, fathers, daughters, sons, with monsters they can't contain,
Overuse a formula, that spells sorry and equals shame.
Hoping for an equation to fade their reptilian brains away.
An addition of double negatives to create a positive reframe
Of a problem without solution, dividing families every day.

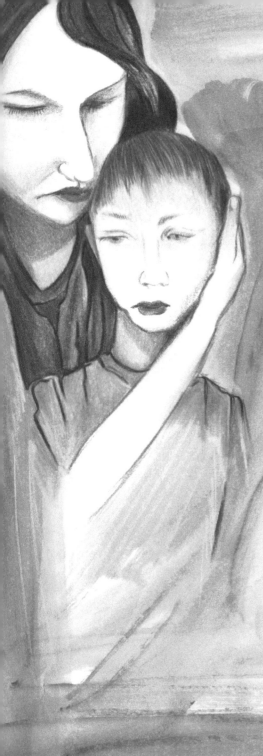

MORALLY CORRUPT

A mother told her son
From the time he was very young
He could live any life he chose
But to follow a path that made him happy.
Turning to her before he'd even reached thirteen
He replied he would choose to never be
And she was morally corrupt
To have brought him into being
Against his will.

Trying to enter his room today
Her brain went into a tailspin of horror
She was met with resistance as she pushed against his door.
She took a deep breath in, believing
If she could force-feed oxygen into her lungs
It would keep him breathing
And I know you are thinking
Why was her first thought that he wasn't breathing?
She was stopped from getting inside
By a rug caught under the door
Not his suicide

But she lives with the knowledge on any day he could decide

It is time to follow through with a plan,

He has planned since he first became aware

This life, is not of his choosing

So why would he choose to stay?

And the mother of this child grown into a man who feels

Misplaced in a space she created for him to fill

Is filled with the conflict of her relationship to him as his mother

Versus that of one human being to another.

What mother validates a child's desire to take his own life?

What mother would want her child to die alone?

What mother tells her son he is wrong

Because the thing he longs for most

Is to never have been here in the first place?

What answer does she give when he says

All of us live just to die

And soon after that the life we lived is forgotten

So, what is the point?

What answer does she give

That would make any difference?

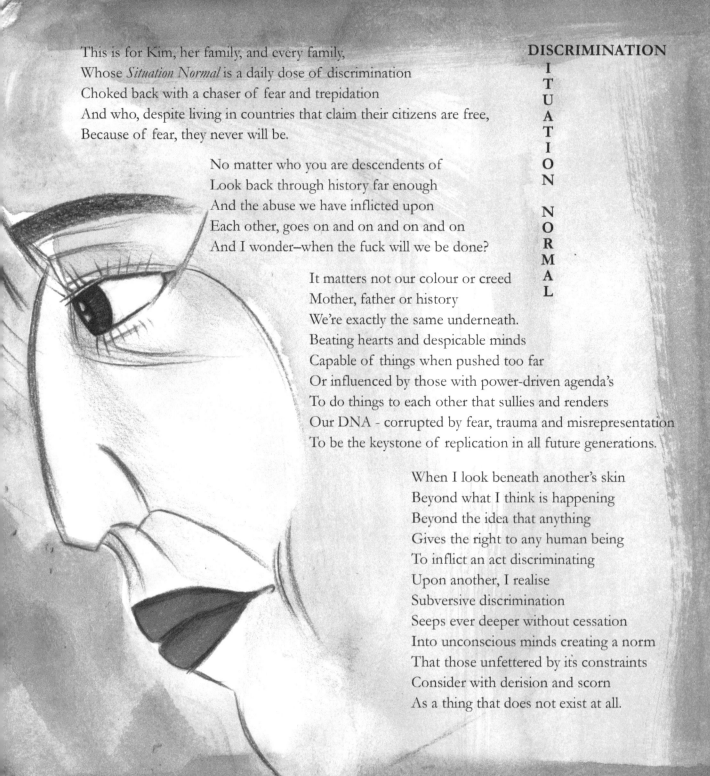

This is for Kim, her family, and every family,
Whose *Situation Normal* is a daily dose of discrimination
Choked back with a chaser of fear and trepidation
And who, despite living in countries that claim their citizens are free,
Because of fear, they never will be.

No matter who you are descendents of
Look back through history far enough
And the abuse we have inflicted upon
Each other, goes on and on and on and on
And I wonder–when the fuck will we be done?

It matters not our colour or creed
Mother, father or history
We're exactly the same underneath.
Beating hearts and despicable minds
Capable of things when pushed too far
Or influenced by those with power-driven agenda's
To do things to each other that sullies and renders
Our DNA - corrupted by fear, trauma and misrepresentation
To be the keystone of replication in all future generations.

When I look beneath another's skin
Beyond what I think is happening
Beyond the idea that anything
Gives the right to any human being
To inflict an act discriminating
Upon another, I realise
Subversive discrimination
Seeps ever deeper without cessation
Into unconscious minds creating a norm
That those unfettered by its constraints
Consider with derision and scorn
As a thing that does not exist at all.

DISCRIMINATION
ITUATION NORMAL

IT DOES!
Consider the reality of just one man's reality
That was posted on the WWW one week in 2020.
A situation of which I cannot speak
Without feeling sick to my stomach.
I certainly could not watch it
Just heard the talk of it and knew the truth of it.
If that man had resisted, spoken out, not stayed passive
As his heart rate accelerated with the fear of knowing he was already dead
As he non-aggressively begged
For that officer to remove his knee from his neck
Hoping for just a flicker
Of compassion -
He would have just been dead quicker.

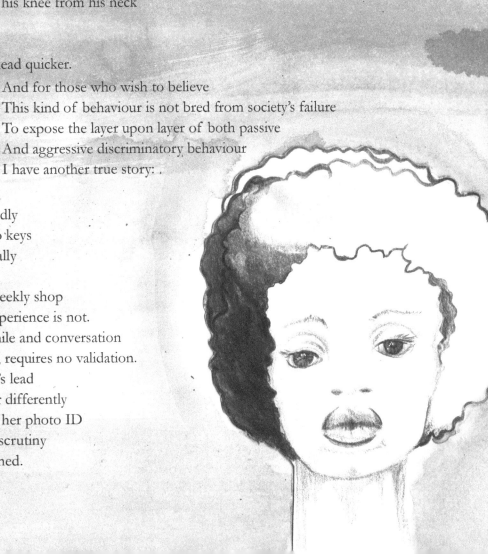

And for those who wish to believe
This kind of behaviour is not bred from society's failure
To expose the layer upon layer of both passive
And aggressive discriminatory behaviour
I have another true story:

Sisters, Ebony and Ivory,
Look as different outwardly
As interconnecting piano keys
Despite sharing biologically
The same parents.
Together they do their weekly shop
An outing shared; the experience is not.
Ivory is served with a smile and conversation
Her payment, by cheque, requires no validation.
Ebony follows her sister's lead
But the cashier treats her differently
Demanding, she present her photo ID
And endure humiliating scrutiny
Before her cheque is cashed.

Ebony—Having been taught by parents who inherently
 Know the world as a place where no matter who your kith or kin
 Or what swanky suburb you live in
 Speaking out can get you in
 A whole heap of trouble if the colour of your skin
 Is Black—
Stands shamed, silent, choking injustice down
While Ivory thinks nothing of going to town
On the cashier demanding, "Why is it okay
To treat my sister differently when
We've paid the same way?"
That cashier gave no answer, I doubt she even knew
But an epiphany was had by some standing in that queue.
And when I was told that story
I realised my daily diet of social dysfunction
Has me making unconscious assumptions
Has me acting without compunction,
Has me giving into the seduction
Of a thing that is an obstruction to the eruption of my true nature; Love.
I realise I've been blind to how entrenched
Discrimination has become.

Discrimination is a colour thing
A racial, religious and gender thing
A privilege versus poverty thing
A power versus powerless thing
An erosive, corrosive debilitating thing
And instead of just surrendering
To what may seem the normal way of things I realise we must all start questioning
Why are we continuing
To sanction acts dehumanising
When, being all the same beneath our skin
There is no need for them at all?

INVISIBLE ME

Gaze beyond your own fragility

Beyond what human eyes can see

Beyond the encoding of society

Decreeing the dimensions

Of the perfect body

Love the self that lies beneath

Only then can you accept

My invisible me

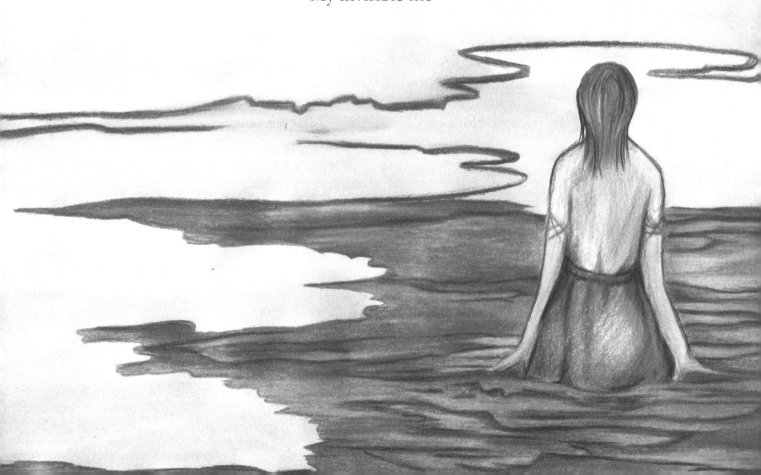

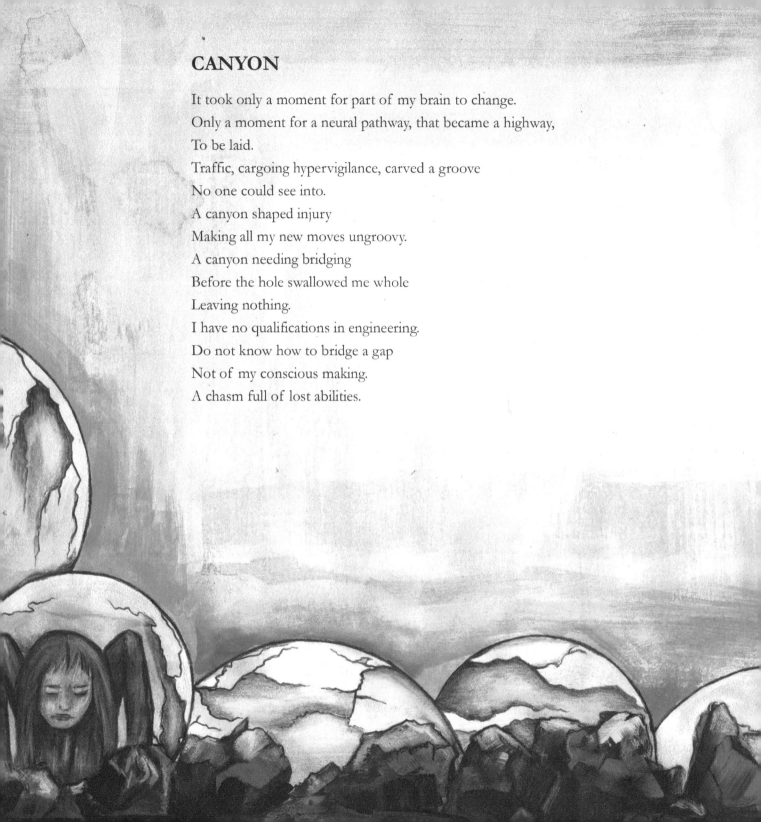

CANYON

It took only a moment for part of my brain to change.
Only a moment for a neural pathway, that became a highway,
To be laid.
Traffic, cargoing hypervigilance, carved a groove
No one could see into.
A canyon shaped injury
Making all my new moves ungroovy.
A canyon needing bridging
Before the hole swallowed me whole
Leaving nothing.
I have no qualifications in engineering.
Do not know how to bridge a gap
Not of my conscious making.
A chasm full of lost abilities.

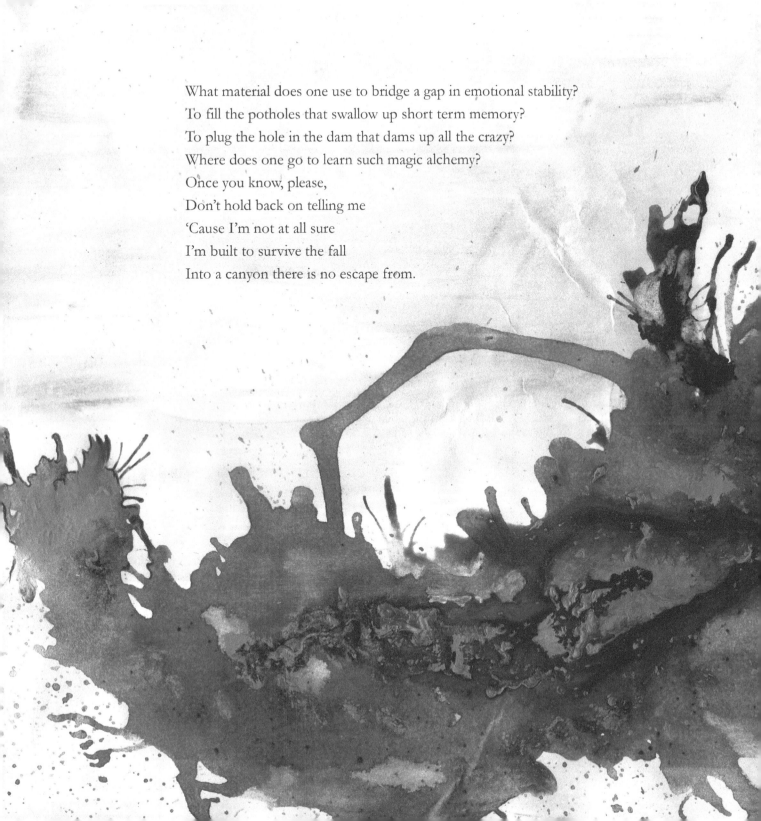

What material does one use to bridge a gap in emotional stability?

To fill the potholes that swallow up short term memory?

To plug the hole in the dam that dams up all the crazy?

Where does one go to learn such magic alchemy?

Once you know, please,

Don't hold back on telling me

'Cause I'm not at all sure

I'm built to survive the fall

Into a canyon there is no escape from.

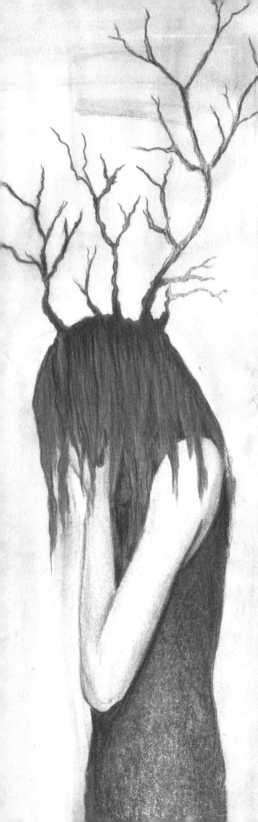

I'M OKAY

Every time you greet me with a, *Hey, how's it going?*
I want to tell you
Unconscious is capsized
In the nucleus of night
Throat, chest, constricted, tight
Body fighting the need for flight
From a terror non-existent metaphored into existence
Decimating sleep, sweat drenching sheets
Forcing *I'm okay* loop-the-looping on repeat
At cyclonic speed that sweeps paralysis free
So finally I can breathe and drift back to sleep

That, this week has been, fine
Panic attacks, attacking, a number, of times
But I am getting used to warning people of my triggers
And heeding trigger warnings to prevent me getting triggered
Although sometimes I am triggered for no reason I can think of
And any reason I require, to reason myself out of
Dry-heaving up adrenalin and panic in the toilet bowl
Is long gone on a holiday it sees no reason to return from

That, there is no comfort to the discomfort
Of being so uncomfortable in my skin
Anywhere on the horizon
So, I tend to, sink in Withering
Unlike the shame that's blossoming
Spreading seeds with the speed of a noxious weed promising
I will never be free
It owns me

That, tears threaten to spill
From eyes that fill indiscriminately
I cry with no provocation
I am a pro in the vocation of crying
And the frustration I am sick to death of denying
So, I just stay home

But mostly, I'd want you to know, that
Lonely is a synonym only
For a word yet to be created
To describe the crater cratering into me
Leaving me not quite all here so, never truly seen
Instead, I answer your question with an answer
That will stop you asking questions
And always with a smile I'll reply,
Hey,
I'm good
I'm fine
I'm okay

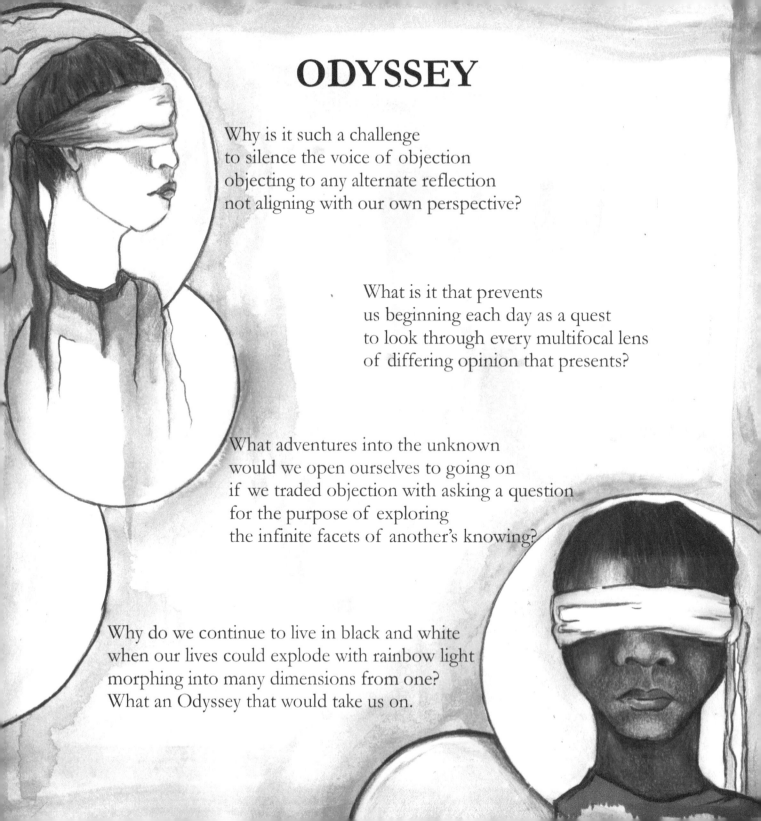

ODYSSEY

Why is it such a challenge
to silence the voice of objection
objecting to any alternate reflection
not aligning with our own perspective?

What is it that prevents
us beginning each day as a quest
to look through every multifocal lens
of differing opinion that presents?

What adventures into the unknown
would we open ourselves to going on
if we traded objection with asking a question
for the purpose of exploring
the infinite facets of another's knowing?

Why do we continue to live in black and white
when our lives could explode with rainbow light
morphing into many dimensions from one?
What an Odyssey that would take us on.

SHAMEFUL

WALLS OF SHAME

A man stirs
In his urban mobile home
Secreting shame within walls
Of flimsy cardboard.

SECRET

Hiding a secret
Burying it deep
Feels like a lie
So hard to keep

Act normal
Clench teeth
Fight to hide
What lies beneath.

CREEPER

Tendrils of shame
Crawl along my spine
Melding with guilt
To deplete over time
Any hope or belief
That love can be mine

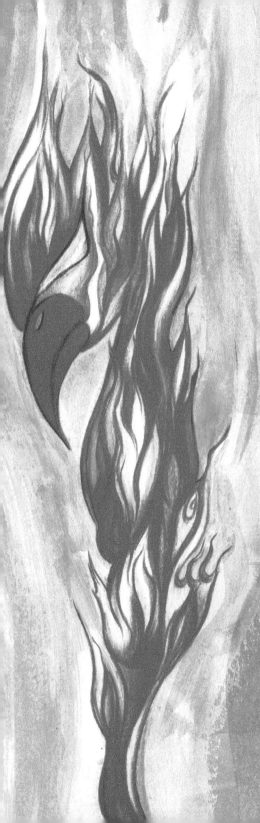

THE SCENT OF 2020

Brought to a standstill by a virus
That burns through tissue, makes us choke
Issues, like a phoenix, have arisen from the smoke
And, like the pungence of rain on hot pavement,
I can taste the bitterness of them at the back of my throat.

Awareness, there is more to global suffering
Than a virus making
Lungs full,
Heavy
Like rain on wool,
Adheres to an atmosphere
Sticky with the fear
Rioting along streets
And whispered in alcoves.
Oppressive, like the cloying odour of cloves,
Their vocalisation
Cannot be masked
By the masks
Covering the mouths speaking them.
There will be no more sweeping them
Under a carpet of nonsense topics of no consequence
Designed in essence to uplift the senses
Whilst numbing us to the senseless suffering of the defenceless.

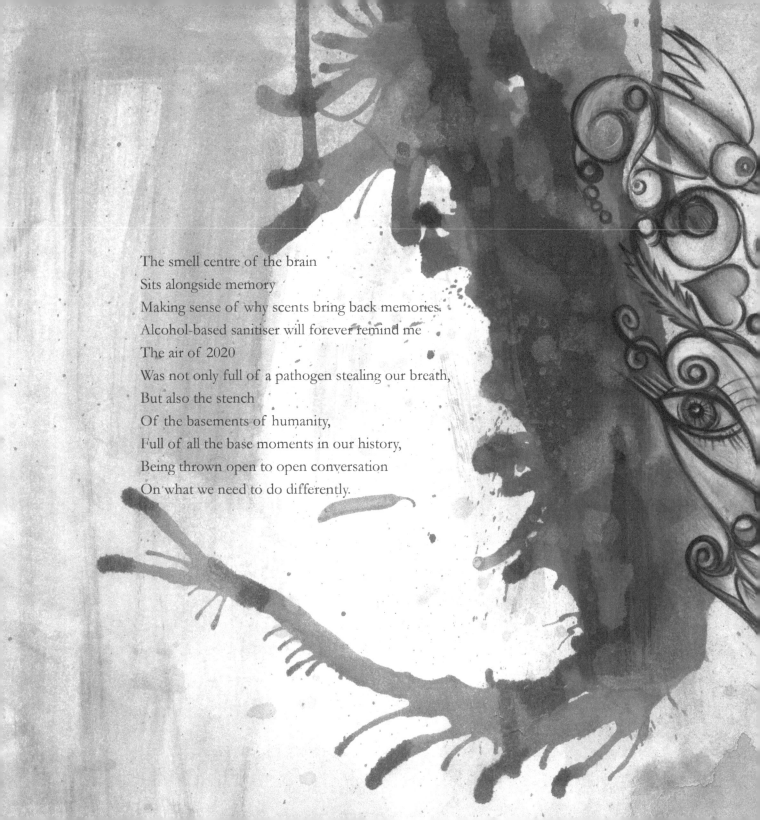

The smell centre of the brain
Sits alongside memory
Making sense of why scents bring back memories.
Alcohol-based sanitiser will forever remind me
The air of 2020
Was not only full of a pathogen stealing our breath,
But also the stench
Of the basements of humanity,
Full of all the base moments in our history,
Being thrown open to open conversation
On what we need to do differently.

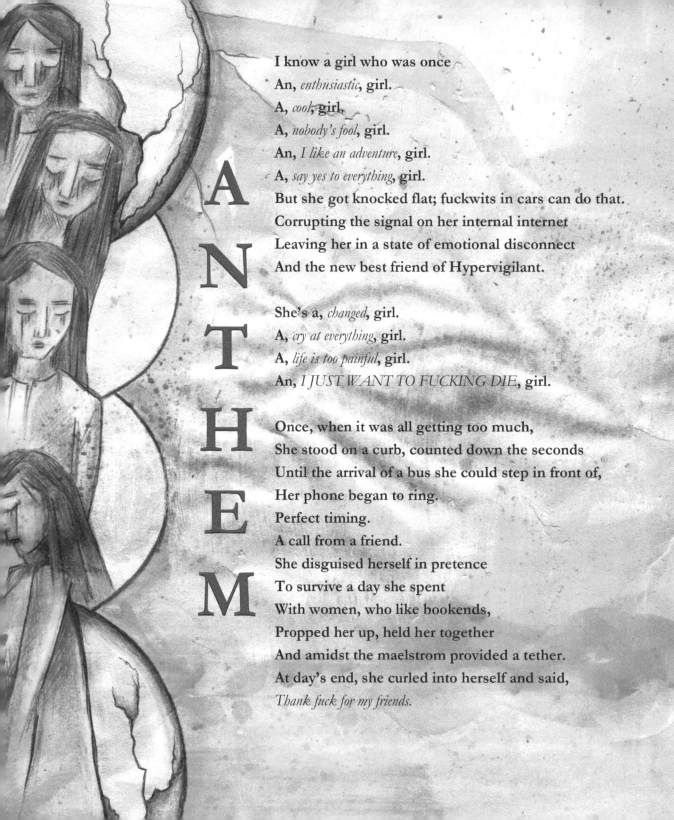

ANTHEM

I know a girl who was once
An, *enthusiastic*, girl.
A, *cool*, girl.
A, *nobody's fool*, girl.
An, *I like an adventure*, girl.
A, *say yes to everything*, girl.
But she got knocked flat; fuckwits in cars can do that.
Corrupting the signal on her internal internet
Leaving her in a state of emotional disconnect
And the new best friend of Hypervigilant.

She's a, *changed*, girl.
A, *cry at everything*, girl.
A, *life is too painful*, girl.
An, *I JUST WANT TO FUCKING DIE*, girl.

Once, when it was all getting too much,
She stood on a curb, counted down the seconds
Until the arrival of a bus she could step in front of,
Her phone began to ring.
Perfect timing.
A call from a friend.
She disguised herself in pretence
To survive a day she spent
With women, who like bookends,
Propped her up, held her together
And amidst the maelstrom provided a tether.
At day's end, she curled into herself and said,
Thank fuck for my friends.

Struck repeatedly by overwhelm and confusion,
She became a walking contusion.
Secreting pain beneath her surface.
The effort seemed hardly worth it
When those without understanding
Offered suggestions condescending, questioning
How much time she was spending
Doing things she enjoyed and then
Naively recommending
She join a gym, or something.

She became an, *angry*, girl.
A, *why is nobody getting it?* girl.
An, *adrenalin filled*, girl.
An, *I can't sleep for nightmares*, girl.
An, *I JUST WANT TO FUCKING DIE*, girl.

Once, when the Hopelessness felt too much
She decided to pull the plug
And filled the bathtub.
About to step in, she heard the door bell ring.
Perfect timing.
It was a friend.
With concern on her face.
Love, in her embrace.
The visit paid dividends
At day's end
She realised she was saved again,
And sobbed into her pillow,
Thank fuck for my friends.

She lost years treading water,
Trying every treatment in the hope it was a cure.
The trauma; debilitating.
The crazy moods; annihilating.
Her guilt and failure; needed medicating.
Her life; so humiliating.

Once, craving death, she stopped procrastinating,
But as she tied the noose in a knot
Her phone dinged.
Perfect timing.
A text from a friend
Insisting she join them for a swim
Clarity.
These women are her angels
Sent to intervene.
Clarity.
They see through her when she pretends
everything's good and she's on the mend.
Clarity.
They love her, despite her whack behaviour.
Are the army at her back, ready to defend her.

I know a girl who was once an,
I WANT TO FUCKING DIE GIRL
Then she realised she had angels.

The angels will never know
How many times their texts and calls
Showed the hollow, frightened girl
She could be
A, *stay in life*, girl.
A, *people care about you*, girl.
A, *taken care of*, girl.

They should know the countless times
Getting through the day depended
On a random interruption from a friend and
They should know she saw it all.
Every kind deed.
The time spent to fill a need.
The daughter that lent a hand
Although too young to understand.
Nothing went unseen.

I know a girl who finally comprehends
Friendship transcends everything.
I know a girl who is starting to feel whole
And each day, as what was hollowed out mends,
She raises a glass full of gratitude
And toasts,
THANK FUCK FOR MY FRIENDS!

Enlightenment

"*Everything we hear is an opinion,
not a fact.
Everything we see is a perspective,
not the truth.*"

- Marcus Aurelius, *Meditations*.

CONTENTS

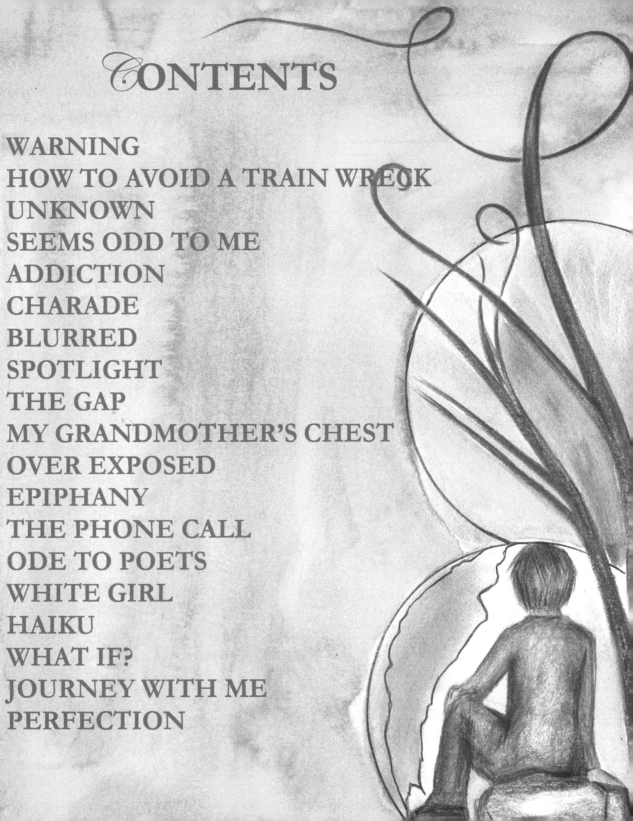

WARNING

I come with a warning.
My themes are dark and non-conforming
and I'm sorry,
'cause I know the only one my demons should hurt is me,
but they purge at random moments
seeking clarity.
If this leaves you feeling fragmented,
you're welcome to leave.

If we began every interaction with a warning somewhat similar,
would we approach life with an attitude far less cavalier?
Would we engage with fellow human beings more transparently?
From streams of thought meticulously edited to intentionally
connect compassionately?
Would this daily statement, alerting each other to character ailments
before entering a trajectory of innately flawed complexity,
broaden our capacity to accept the unsatisfactory elements in humanity?

If we laid out our unique fragments of insanity
And without the hostility, born of feeling guilty,
said, *there you go, they're the crazy bits of me,*
would we cease taking everything so personally?
Would we finally be free from acting out so perversely
in our clumsy attempts to disavow and disguise the pieces
we think ugly?

With nothing left to hide,
could we tear down the structures that provide
scaffolding to the stories which reside in our minds,
dictating the how and why
of our treatment of each other?

Would we exhale with relief or disbelief
to discover we've been operating from a brief
of perspectives whose chief role
was to give us a sense of measure?
Just as distance over speed gives us concept of time,
race plus location offers probability of crime
and wealth over minority equals not equality,
but a concept your life has a value
higher or lower than mine.

If every interaction began with a preface
of all the reasons why we may not choose kindness,
would the words spoken aloud find us
realising they're not reasons, but prejudice
stemming from a story which *is* our story,
but need not define us?

HOW TO AVOID A TRAIN WRECK

Have you ever experienced a pivotal point in your personal timeline?
You know, that point where if pivot were possible and you could go back in time
to do a retake, remake, re-instiga-tion of events,
you could prevent the train wreck, that when you last checked
seemed to lay the track for the rest of your life and, with the benefit of hindsight,
you'd do anything to put it right?

Truth one:
You can't go back.
You can only move forward, reloading carriages.
Carefully excluding, occluding and removing all
the detonators that derailed you and will only hold you back.
What has been before does not make what is to come, a fact.
Best turn those creepers into sleepers
load up with believers and don't look back.

Truth two:
Ignore people preaching hollow parables
that you deserve to do whatever makes you happy,
as though any station named Instant Gratification
could offer you anything but a short-lived flirtation
and ongoing fixation with the percolation
of dopamine in your bloodstream.
The point being - you can only experience it alone
making the trip pointless and hollow
and once GRAT and CATION are flying solo
you're left with IF, and a tiny chance
of arriving at the Happiness Chateaux.

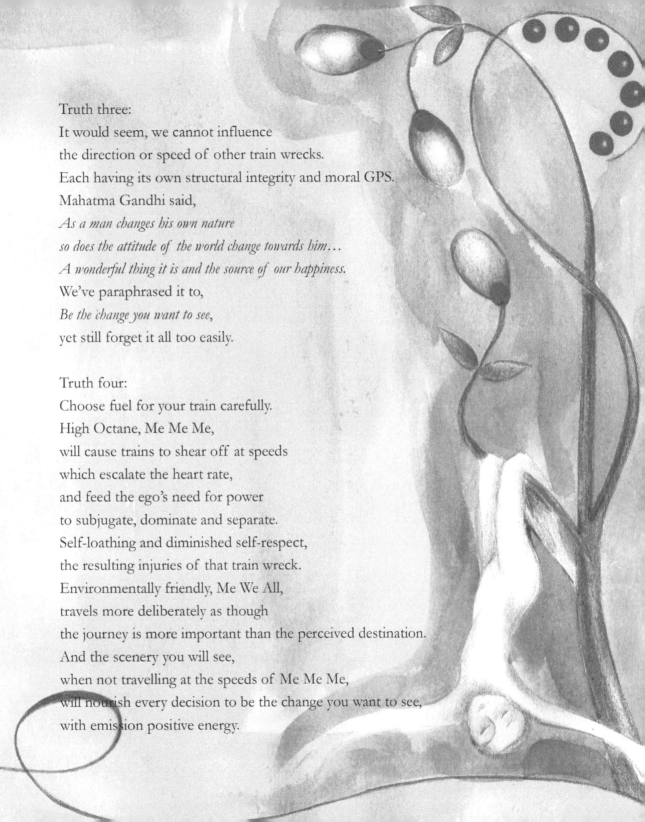

Truth three:
It would seem, we cannot influence
the direction or speed of other train wrecks.
Each having its own structural integrity and moral GPS.
Mahatma Gandhi said,
As a man changes his own nature
so does the attitude of the world change towards him…
A wonderful thing it is and the source of our happiness.
We've paraphrased it to,
Be the change you want to see,
yet still forget it all too easily.

Truth four:
Choose fuel for your train carefully.
High Octane, Me Me Me,
will cause trains to shear off at speeds
which escalate the heart rate,
and feed the ego's need for power
to subjugate, dominate and separate.
Self-loathing and diminished self-respect,
the resulting injuries of that train wreck.
Environmentally friendly, Me We All,
travels more deliberately as though
the journey is more important than the perceived destination.
And the scenery you will see,
when not travelling at the speeds of Me Me Me,
will nourish every decision to be the change you want to see,
with emission positive energy.

For those thinking,
 I live my best life and shit is still happening to me,
 Spoiler alert.
 Refer to truth three.
The only train we choose fuel for
is our own, so chances are along the way
you'll be impacted, slowed down, face a detour
from a train wreck that aint your own.
This is where you choose what fuel you want to use.
Me We All is pumped on board slowly allowing time
to do a, *what is needed?* barometer check.
Your moment of truth,
to consciously choose your role in that train wreck.

Final truth:
You will find pleasure in a plethora of stations offering instant gratification,
but if you think that pleasure is happiness, you are mislead, misinformed, mistaken.
Happiness comes not from the pursuit of it as though the capturing of it
will serve as a once off, fix it, super hit
that can be contained simply for the benefit
of self.
It is the result of putting in the effort
to create deep and meaningful connection
with those who come into your orbit.
It is the consequence of doing a regular self-check
and repeatedly choosing fuel,
that won't combust into a train wreck.

UNKNOWN

I am starting to think,
When we come to know something we previously didn't
That helps us understand another human's experience,
Embracing change and evolving our psychology
Can be as healing and powerful as an apology.

I always thought, the extent of treating people right
was to reach out to others with compassion and kindness.
It has taken some time, but I have come to realise
Defending, instead of witnessing, those being treated without decency,
Falls within the boundaries of treating others decently.

I thought the term *respectfully* had universal meaning.
Using manners, being quiet when other people are speaking.
I've found, that depending on with whom you're speaking,
There are subtleties and nuances that lend variations to its meaning.

I look forward with curiosity, to learning things unknown to me.
To witnessing change as inherited belief systems start dissolving.
Can we explore perspectives not considered
without anger and frustration?
Can we learn to listen so we can ask the right questions?
Can we set a global intention to honour others' opinions?
Can we make space to embrace knowing things we didn't?
A social reboot is cresting the horizon
but until we concede, without our ego's we know nothing,
conduits for solving global ills, will stay hidden.

S Have you ever noticed, people carrying the label disabled,
are really just abled differently to what us neurotypicals call normality?

E Have you noticed that if a disability is apparent visually,
generally, it attracts no scrutiny,

E but if it is hidden within one's head,
you are required to somehow prove it instead?

Seems odd to me

M Have you caught yourself judging a random parent harshly,
for the behaviour of their child who does not look disabled externally

S yet is challenged and challenging, behaviourally?
Have you caught yourself, subliminally, sneering at mothers like me?
Silently telling me, as I smile back at you weakly,
that I should get my boy under control or, just leave?

O Please. Be brave. Don't avoid my gaze with your eyes full of judgement.
Instead, have the courage to offer me encouragement.

D To engage me in perhaps the only conversation of my day
that gives my son and I a way

D of fitting into your normal, momentarily.
Did you know that when you judge me,
you are ultimately telling my child he's somehow less than he should be?
Really, it is your unwillingness to see

TO that although what he brings to the table looks a little differently
to the norm you want to see,

ME it is not wrong.
Your blinkers are holding him back from being all he can be.
That you can't see it...

Seems odd to me

Research shows, many humans labelled with ASD
have an IQ that is extraordinary, yet they often test poorly.
Educators and Employers continue to place emphasis on high scoring
as a measure of what a person has to offer
ignoring all the research that is costing millions of dollars.

Seems odd to me

The definition of power is,
The ability to direct or influence a course of events or a person's behaviour
Yet the people we vote into power show great reluctance
to fix a system so broken and robotic
that any tick or cross that falls outside a box
denies differently-abled humans support
with a non-negotiable full stop.

Seems odd to me

Please hold back the snide whispers and judgy gossip
you wish to whisper deep into consenting ear canals
feeding auditory nerves with waves of sound
that evaporate only to precipitate judgement down on me.
Next time you catch yourself jumping to conclusions
about a parent whose child is acting challengingly,
try responding compassionately
because if the powers that be
continue using their power inconsequentially,
the lives of these parents and children will forever be challenging.
And, but for the grace of God, or whoever
you think decides these things,
it could have been you, not them or me.
That you can't see that...

Seems odd to me.

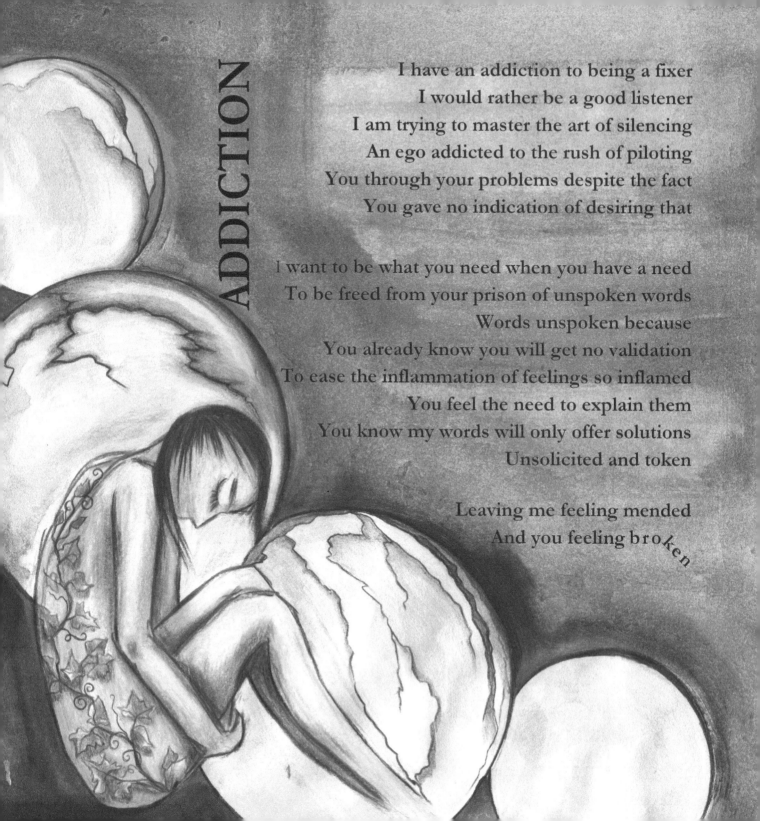

ADDICTION

I have an addiction to being a fixer
I would rather be a good listener
I am trying to master the art of silencing
An ego addicted to the rush of piloting
You through your problems despite the fact
You gave no indication of desiring that

I want to be what you need when you have a need
To be freed from your prison of unspoken words
Words unspoken because
You already know you will get no validation
To ease the inflammation of feelings so inflamed
You feel the need to explain them
You know my words will only offer solutions
Unsolicited and token

Leaving me feeling mended
And you feeling broken

This need to feed an ego ungracious is an affliction
Easily remedied with the conscious decision
To shut my mouth and start to listen
A decision to dig out that seed that grows into
Dis
ease
Beneath my skin
If not fixing things

Responsibility to get clean is my own
But you must not to condone
Any actions of mine that show
I am giving in.
Tell me lovingly you need me listening only
Tell me repeatedly my ability to fix things
Is not how you measure me
Until the addiction of calculating self-worth
By the number of problems I solve
Has lost its appetite
And
I
am
enough

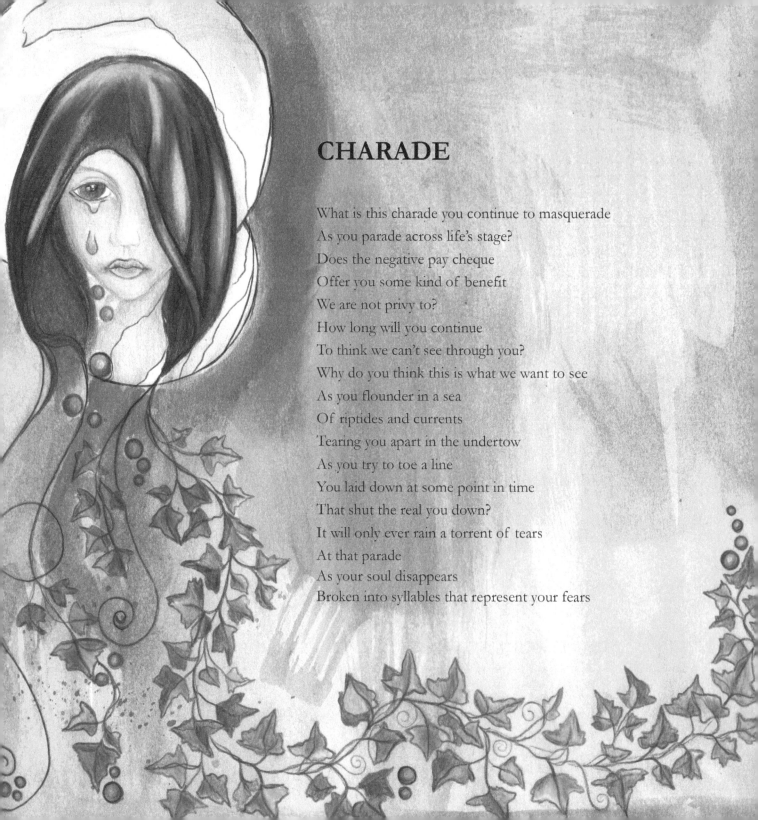

CHARADE

What is this charade you continue to masquerade
As you parade across life's stage?
Does the negative pay cheque
Offer you some kind of benefit
We are not privy to?
How long will you continue
To think we can't see through you?
Why do you think this is what we want to see
As you flounder in a sea
Of riptides and currents
Tearing you apart in the undertow
As you try to toe a line
You laid down at some point in time
That shut the real you down?
It will only ever rain a torrent of tears
At that parade
As your soul disappears
Broken into syllables that represent your fears

BLURRED

Frag
men
ted

Dis ected
conn

Not seen
Not heard

Isolated

Lonely

Sense of self

BLURRED

Focus changed
By distance enforced
Family connects
Sense of self endorsed

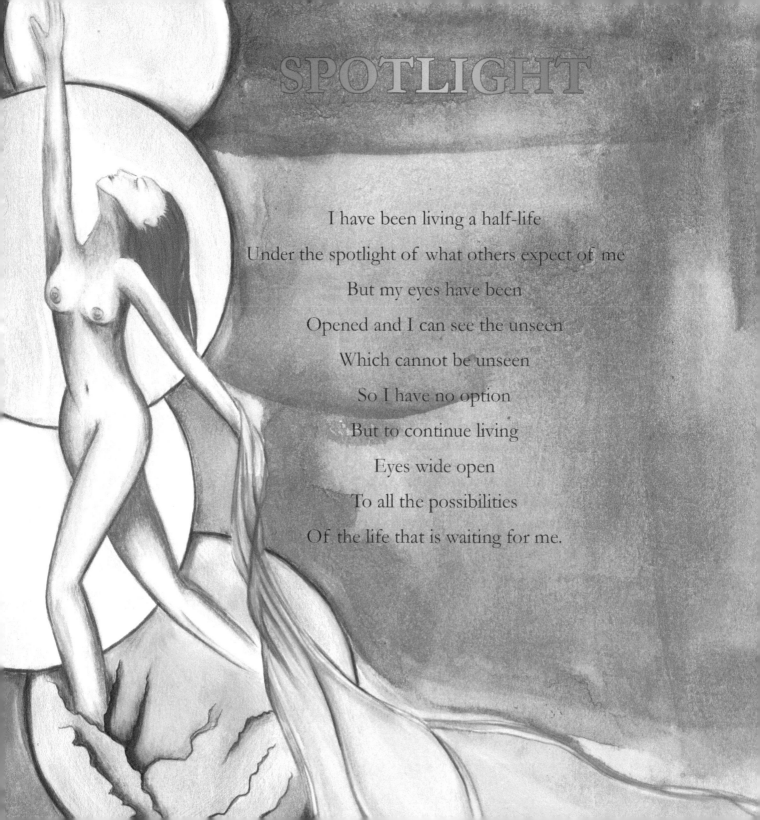

SPOTLIGHT

I have been living a half-life

Under the spotlight of what others expect of me

But my eyes have been

Opened and I can see the unseen

Which cannot be unseen

So I have no option

But to continue living

Eyes wide open

To all the possibilities

Of the life that is waiting for me.

THE GAP

Clickity-clack train on track

Tormented, I'm desperate to step into the gap

The concept of ending my torturous life

Lures me with promise of silent delight

This is not normal, I'm clearly insane

Evidence still I should not remain

Thought after thought sprint through my brain

Survival instinct screams ringing refrain

Step back from the line
Step back from the line
Give the pain time to morph into benign

Clarity snaps

I choose hope, not track

As the train races by I step back from the gap

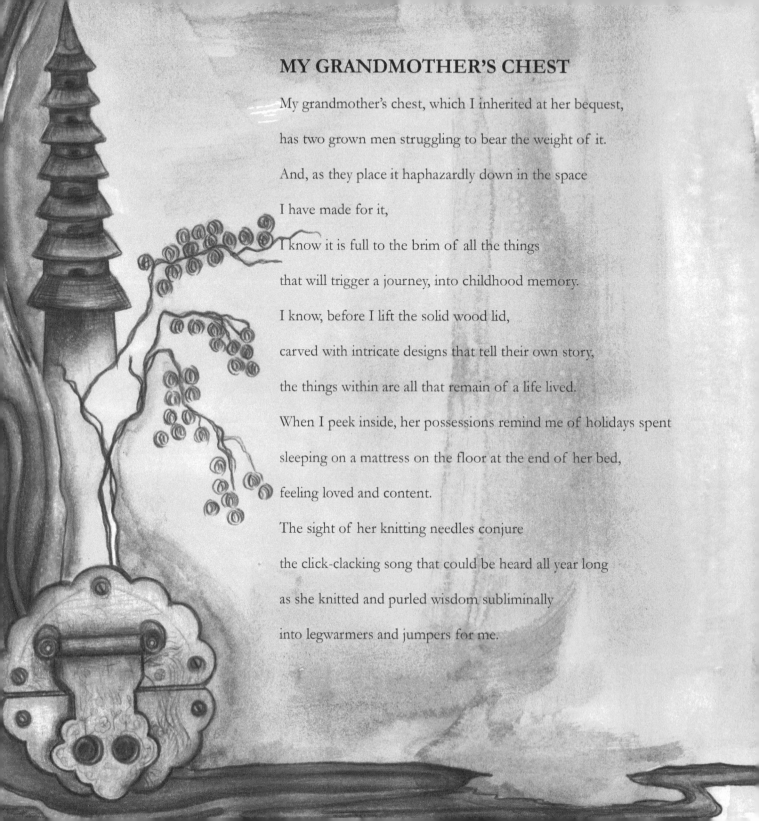

MY GRANDMOTHER'S CHEST

My grandmother's chest, which I inherited at her bequest,

has two grown men struggling to bear the weight of it.

And, as they place it haphazardly down in the space

I have made for it,

I know it is full to the brim of all the things

that will trigger a journey, into childhood memory.

I know, before I lift the solid wood lid,

carved with intricate designs that tell their own story,

the things within are all that remain of a life lived.

When I peek inside, her possessions remind me of holidays spent

sleeping on a mattress on the floor at the end of her bed,

feeling loved and content.

The sight of her knitting needles conjure

the click-clacking song that could be heard all year long

as she knitted and purled wisdom subliminally

into legwarmers and jumpers for me.

I can picture the hot afternoons spent inside with the curtains drawn

as I hold a small cardboard box with its corners torn

containing two tiny decks of cards, one pink, one blue

that she would use,

to teach me patience.

And I wonder if these are the things

she wanted to leave me with.

Did she really want me to have her treasured game of Scrabble,

kept immaculate in its box to remind me of

the incredible vocabulary she passed on by placing letters on a board,

when instead, she could have shared it, sharing words?

Words she kept trapped

beneath a ribcage that should have snapped

under the weight of all the horrors unsaid and packed back

at the back of her throat that surely ached

with the constraint of their containment.

She went to her death; chest heavy.

Leaving me a heavy chest of things

that tell me nothing of the life she lived.

She went to her death; chest heavy.

Leaving me without the most important thing—her story.

She went to her death; chest heavy,

and I now have a heavy chest of memories

that are only my side of her part in my story.

I am sorry, now I know what she boxed up inside her body,

I could never unpack her chest the way I am unpacking this one.

Taking each item with reverence and gentleness.

Examining, validating and rehoming it

so eventually there would be an empty space of weightlessness.

An empty space to make breathing space

in a chest that must have always felt breathless

under the weight of violations inflicted upon it.

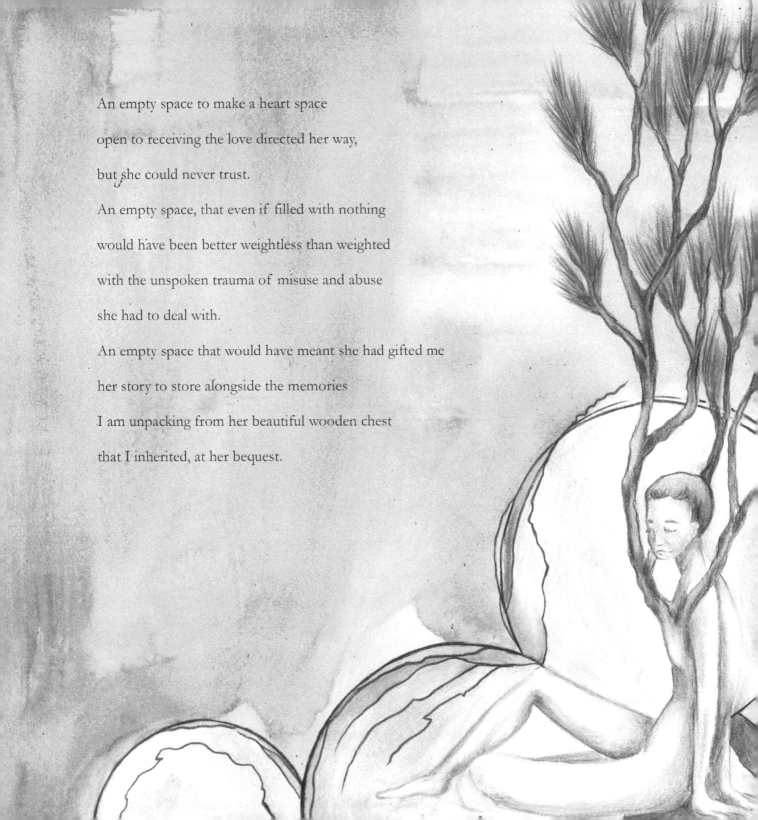

An empty space to make a heart space

open to receiving the love directed her way,

but she could never trust.

An empty space, that even if filled with nothing

would have been better weightless than weighted

with the unspoken trauma of misuse and abuse

she had to deal with.

An empty space that would have meant she had gifted me

her story to store alongside the memories

I am unpacking from her beautiful wooden chest

that I inherited, at her bequest.

OVER

If the world is a reflection of our inner intention,
is the need to be objectified, what us women are craving inside?
When we head outside feeling the need to justify
wearing what makes us feel great, should we hesitate?
Change, to accommodate the lust of men,
which we are told cannot be controlled,
because if we don't,
we become the instigators of their uncontrolled behaviours?

If we choose to wear the skirt tonight
that daddy told us we should not wear tonight;
if we turn his words into a fight, telling him he has no right
to tell us the overexposure of our upper thigh,
makes us fair game in a game we don't want to play,
does our refusal to cover up, make your uninvited advances okay?

Do we need to assume there are still guys convinced
that what we wear,
how we apply makeup and style our hair
is solely for their benefit?

Is it our responsibility to take responsibility
for estimating the probability
of whether an outbreak of toxic masculinity
is going to ruin our evening?

EXPOSED

Why, within this topic of sexual culpability,

are women primarily

considered to be at fault when receiving unwanted attention,

yet, in situations where full consent is given,

we find ourselves in the juxtaposition

of being told our experience of exquisite pleasure

was controlled solely by the giver;

because he's such an accomplished fucker?

And then there are the men of gentlemen calibre,

affected maybe, by the way we appear

yet resisting all urge to join in with the hagglers,

proving control is not outside of achievable parameters.

And yes, I know, there are plenty of women who are just as prone

to feeling lustful feelings, they don't always want to control.

BUT,

where a no means no when a man says it,

if a woman says no, she's often coerced,

OR,

assumed to be saying yes because she had the nerve,

to turn up in a dress that hugged at all her curves.

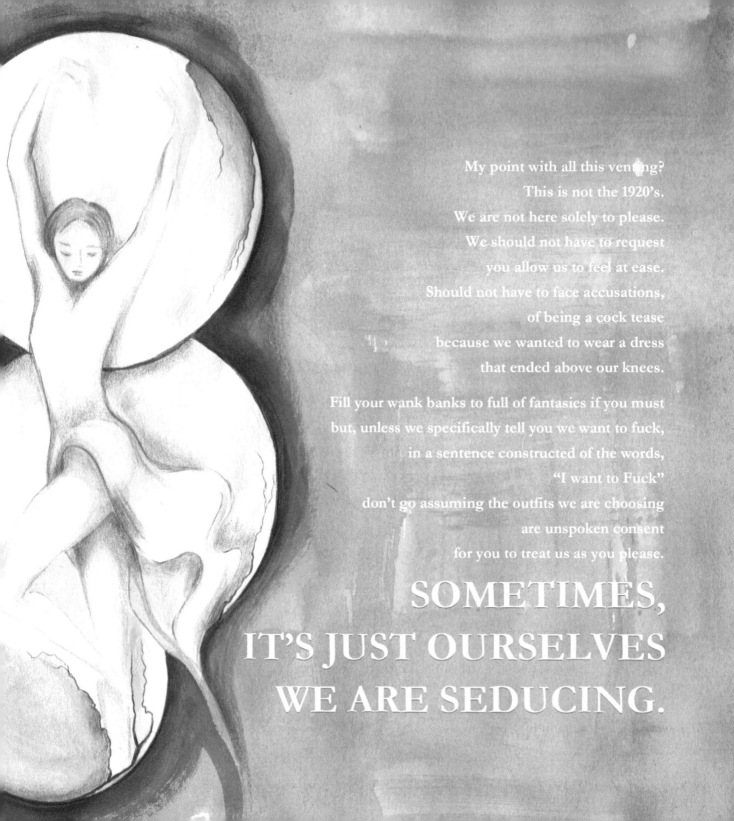

My point with all this venting?
This is not the 1920's.
We are not here solely to please.
We should not have to request
you allow us to feel at ease.
Should not have to face accusations,
of being a cock tease
because we wanted to wear a dress
that ended above our knees.

Fill your wank banks to full of fantasies if you must
but, unless we specifically tell you we want to fuck,
in a sentence constructed of the words,
"I want to Fuck"
don't go assuming the outfits we are choosing
are unspoken consent
for you to treat us as you please.

SOMETIMES, IT'S JUST OURSELVES WE ARE SEDUCING.

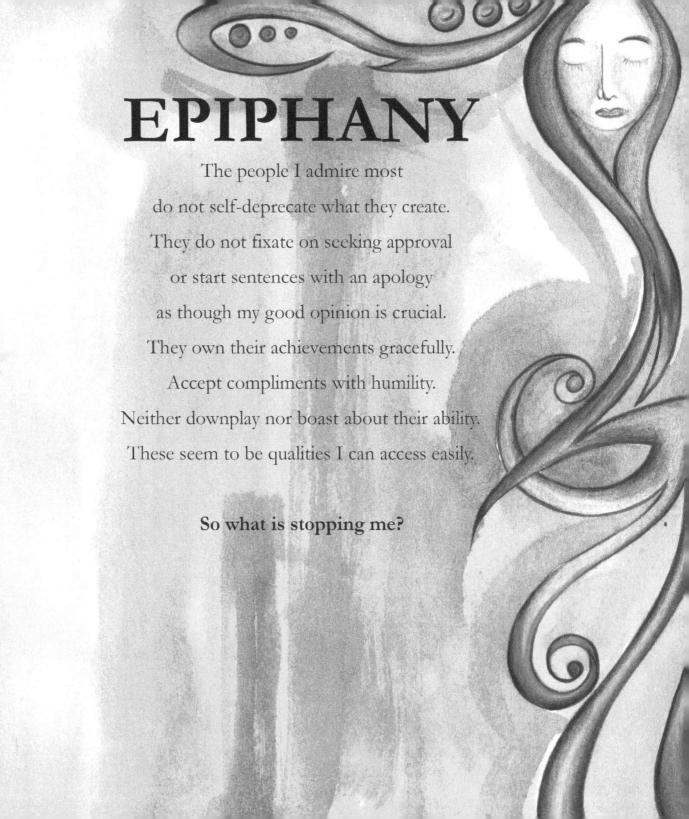

EPIPHANY

The people I admire most

do not self-deprecate what they create.

They do not fixate on seeking approval

or start sentences with an apology

as though my good opinion is crucial.

They own their achievements gracefully.

Accept compliments with humility.

Neither downplay nor boast about their ability.

These seem to be qualities I can access easily.

So what is stopping me?

THE PHONE CALL

We've been expecting a phone call,
delivering a message that's becoming normal.
A symptom of something viral
sweeping across borders and oceans,
bringing oceans of tears to our borders.
It came today, caller ID on display,
we knew the words, *I'm sorry I have bad news,*
would put into jeopardy the financial security of our family.
Instead, *I'm sorry, a colleague has passed-away at home,*
came down the line in quiet monotone
and we instantly recognised, the words were code for suicide.

A job loss became a life lost
A man's name on a FIFO roster
permanently crossed off.
Any chance of being rostered back on
or attending his child's first birthday is forever gone.
Any opportunity to tell him, *Hey, things will be okay,*
vanished in an instant today.

We have seen, since the onslaught of COVID-19,
the globalisation of human suffering.
Humanity reaching out whilst staying in
posting and streaming all manner of things
in an attempt to circumvent, *Alone,* manifesting

But, along with sanitation and isolation,
has come a growing inclination towards profit rectification
and a new pandemic featuring set after set
of job loss setbacks and backs set back into corners
there is no escape from,
is proving as deadly as the virus.

When this company, with operations globally,
started talking redundancy to cut costs to preserve profits
which realistically, even if halved would still be profit enough
to ensure no person on their payroll need be told they are unnecessary,
it was not their intent to leave
A child
A family
A wife
with a human-shaped hole in their lives,
but they did and I have to wonder if
the decision makers in these multi-national companies know,
they could choose to extend job security,
instead of new facilities, across the globe.
How can they not know,
the antidote to human suffering is hope?

AN ODE TO POETS

Imagine being the kind of person whose speciality
Is stringing syllables into story.
Creating musicality that lays a beat on the eardrums
Strumming at the heart strings
Making you feel things about things
You never thought you had feelings about.

Imagine being the kind of person
Who could awake from a dream mid-stream
Throw back the bed sheet
To cover a paper sheet in words.
Sentences that capture a thread
An obscure tangent of what the dreamer dreamt
That when read form images
That make perfect sense.

Imagine specialising in playing with words.
Writing verse after verse of word play
That is not only clever but has something to say
About something worth saying.

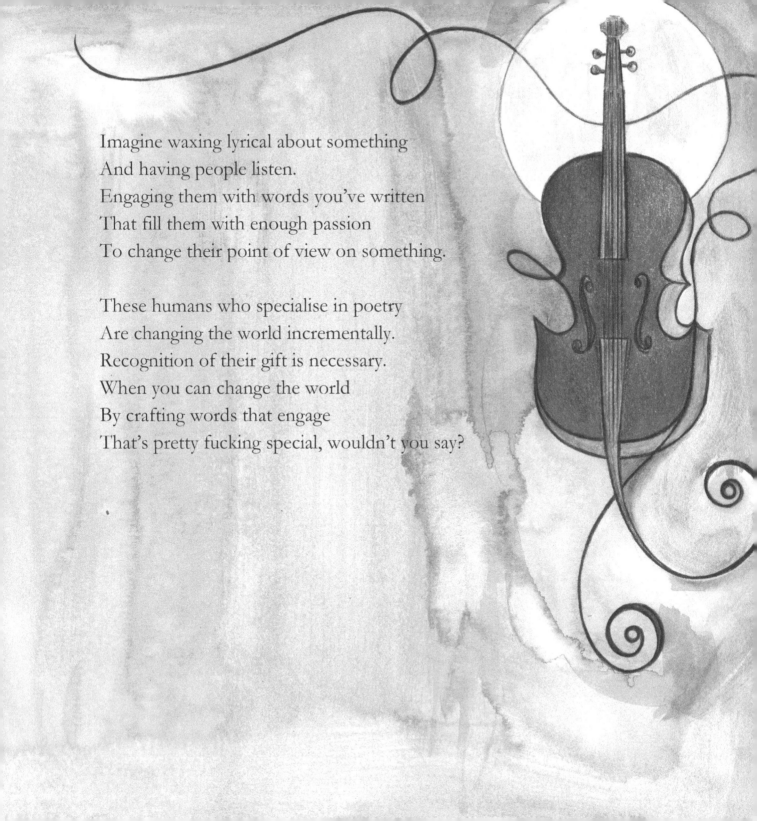

Imagine waxing lyrical about something
And having people listen.
Engaging them with words you've written
That fill them with enough passion
To change their point of view on something.

These humans who specialise in poetry
Are changing the world incrementally.
Recognition of their gift is necessary.
When you can change the world
By crafting words that engage
That's pretty fucking special, wouldn't you say?

WHITE GIRL

I am a middle-aged white girl
given opportunities of privilege.
So, I will not commit the sacrilege
of complaining about anything I perceive is
holding me back from achieving.
I will not condescend to tell you I know what you have been through
just because I once had an experience in a place where my white skin
made me the minority and I was shaken categorically
by the fear that boxed me in.

That would be a poor and naïve attempt
to bridge the gulf of pain and suffering
that breeds contempt between us.
What I will do is use my mouth to ask you what I can do.
What would truly make a difference to you?
What action can I take that will validate
everything you have been subjected to?
I will use my ears to hear you and my actions
to show that I know, any system masquerading
as help under the guise it would be of help
if you would just model the behaviour
it wants you to,
is a system that is bro

k

e n

–not you.

This is my truth and truth be told
there are many such as me who want no power over you.
We believe the need to exert control over others
for the soul purpose of creating clones of us, is ridiculous!
That the idea of you speaking English in your own dialect
somehow intimates disrespect, is preposterous!
That subversive discrimination is thriving
and you have little option but to keep surviving, is monstrous!
In a country that celebrates its diversity outwardly
is it not time to focus inwardly?
Relinquishing the need to exert power over others
will enable us to come together as sisters and brothers.
A beautiful metamorphosis of surviving into thriving.

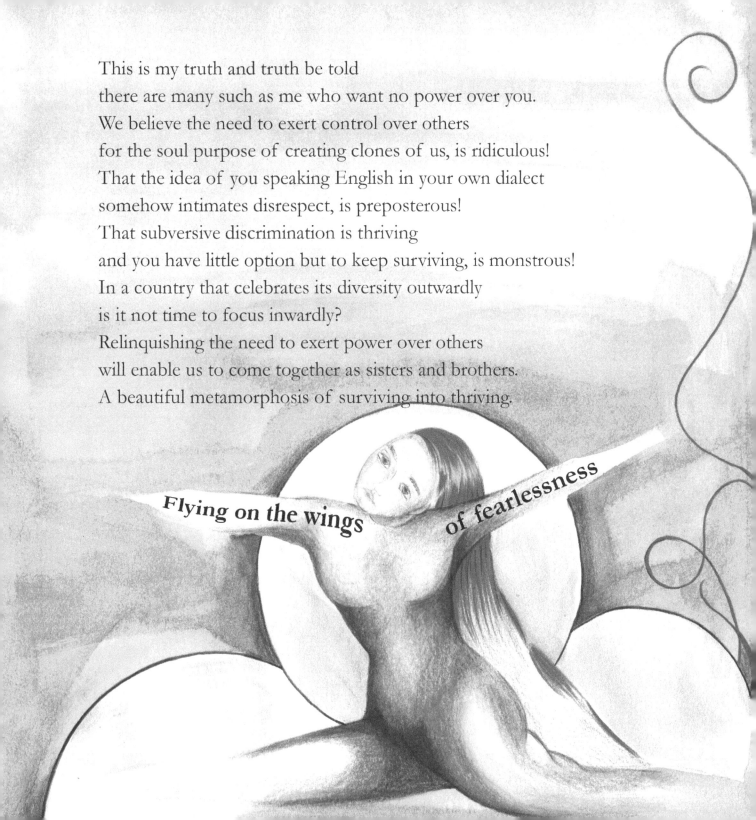

Flying on the wings of fearlessness

HAIKU

DEBT FREE

A mother's love is reflected in every **DIAPER** changed

Love is not a debt that needs to be **REPAID**

MAZE OF PAIN

```
EMOTION  IS  A

S  INTO      A         CONUNDRUM
T                      C
H                      O
G       P    A         N
U       AI   M         U
O       N    A         N
H       OF   Z         D
T            E         R
YM                     U
TWISTING               M
```

WHAT IF?

What if we realised
Our imagination
Is the awakening from hibernation
A life of our own creation
Awaiting manifestation?

What if we let go
Of deep-seated beliefs
That would have us believe
We are limited by the life
We already live?

What if…?

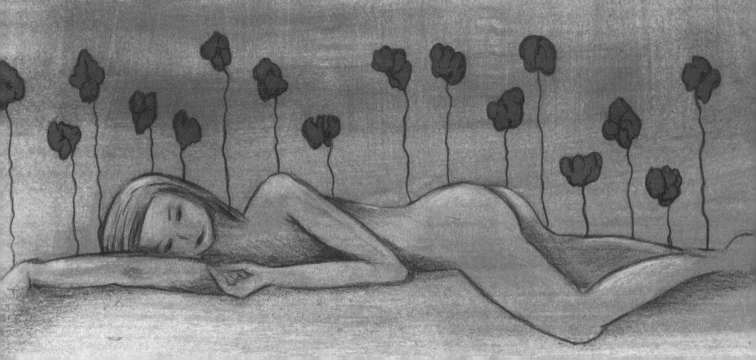

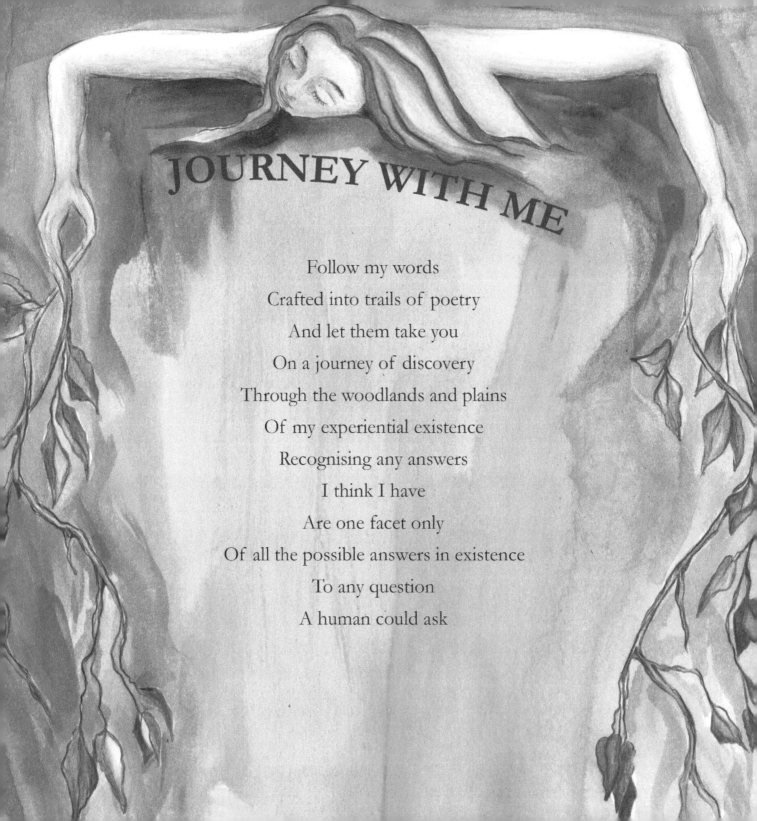

JOURNEY WITH ME

Follow my words

Crafted into trails of poetry

And let them take you

On a journey of discovery

Through the woodlands and plains

Of my experiential existence

Recognising any answers

I think I have

Are one facet only

Of all the possible answers in existence

To any question

A human could ask

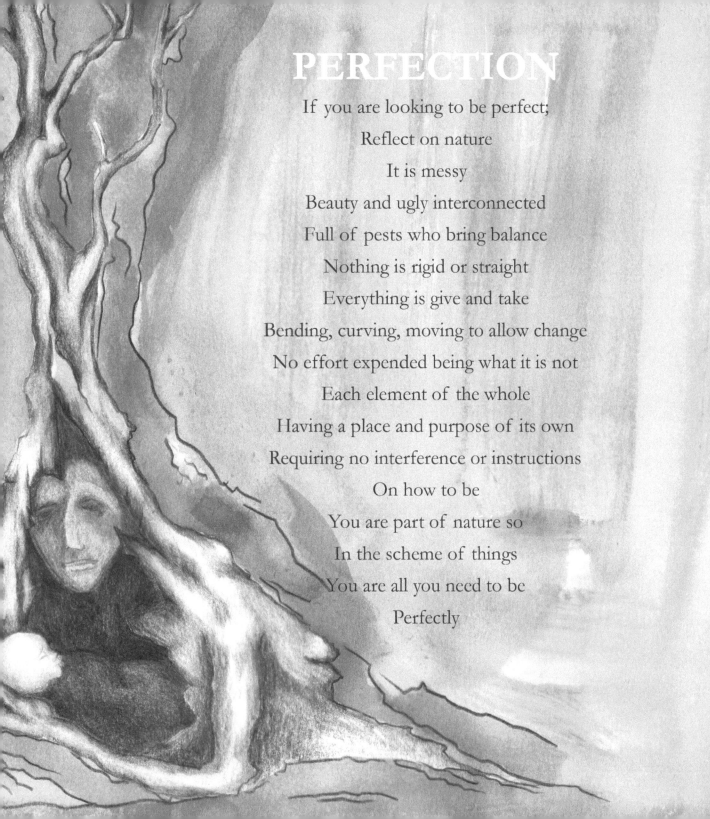

PERFECTION

If you are looking to be perfect;

Reflect on nature

It is messy

Beauty and ugly interconnected

Full of pests who bring balance

Nothing is rigid or straight

Everything is give and take

Bending, curving, moving to allow change

No effort expended being what it is not

Each element of the whole

Having a place and purpose of its own

Requiring no interference or instructions

On how to be

You are part of nature so

In the scheme of things

You are all you need to be

Perfectly

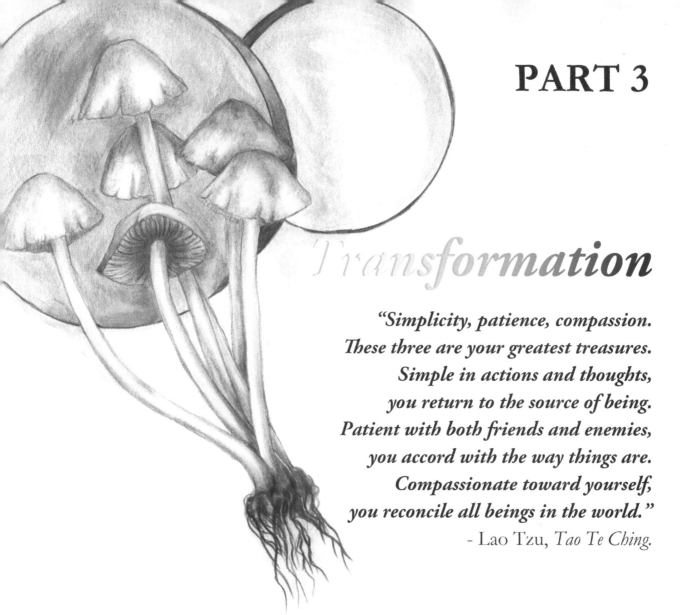

PART 3

Transformation

*"Simplicity, patience, compassion.
These three are your greatest treasures.
Simple in actions and thoughts,
you return to the source of being.
Patient with both friends and enemies,
you accord with the way things are.
Compassionate toward yourself,
you reconcile all beings in the world."*

- Lao Tzu, *Tao Te Ching.*

CONTENTS

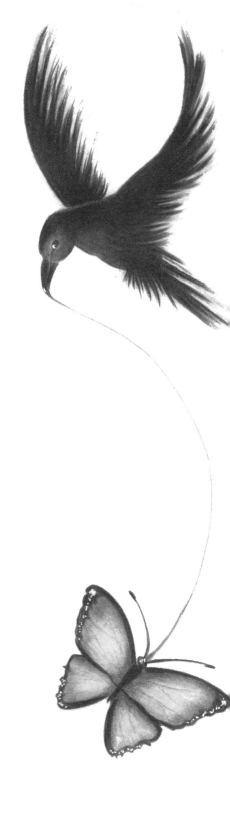

LUMINOSITY

Lychnidiate listless life. Literally lovingly losing

Unambiguous unwillingness undermining

Manifesting magnificence, magically

Incandescent. Interestingly, iconic

Neon nascent nova naturally

Obvious, obligingly

Shine scintillant.

I ll u m inating

Transmuted,

You

TRANSFORMED

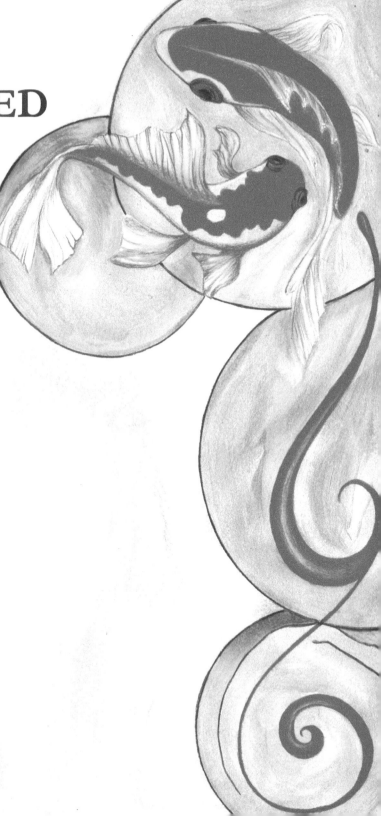

Joy worn upon a face
For all and sundry to see
Brings its own delight
That few can fight the
Urge to resist and why
Would you resist a smile?

Why would you resist
The gift or the chance to give
That which costs nothing?
Why would you resist
What is exquisite in its
Spontaneity
And can convey things
No words can say with the same
Raw alacrity?

Why would you resist
Any opportunity
To be transformed?

HEARTBEAT

I wonder,
if we could tune into the rhythmic rhythm of heartbeats,
would it make obsolete, our constant need
to guess at what's on other people's minds?

If we could see inside
and this tell-tale sign was our guide to guiding us through
the multitude of emotions triggered in others by the things we do,
would we take more care to choose the words and actions we use
to express our truth?

Unfortunately,
although many of us wear our hearts on our sleeves,
our heartbeats cannot be seen.
You cannot know the path we have walked
that makes our hearts balk at the things not talked about.

Maybe the best we can do is trust that in all of us
there are dark parts that set our hearts pacing,
our minds racing, our emotions unlacing out of control
triggering a need to take control and lash out with words
before taking into account what exactly
our perceived perpetrator may be accountable for.

Are they the devil with hearts blackened?
What was the intention behind their words and actions?
Can these things be ascertained in private conversation
before conversation, showing you up as a person
with no integrity, instead of one hurting,
takes place in a public forum?

As creatives we create our creations based on
the dark and light that comes to light in the public spotlight.
We process the plethora of feelings that flood our bodies
when anything happens that embodies the beliefs
triggered by our own stories.
When we take offence; tear each other down,
we are shutting each other down,
down-playing, the power of a question.

Where will we or the rest of the world be
if we have to cease creating because the possiblity
of destructive repercussions emerging,
despite innocence of intent behind the creating,
is too confronting?

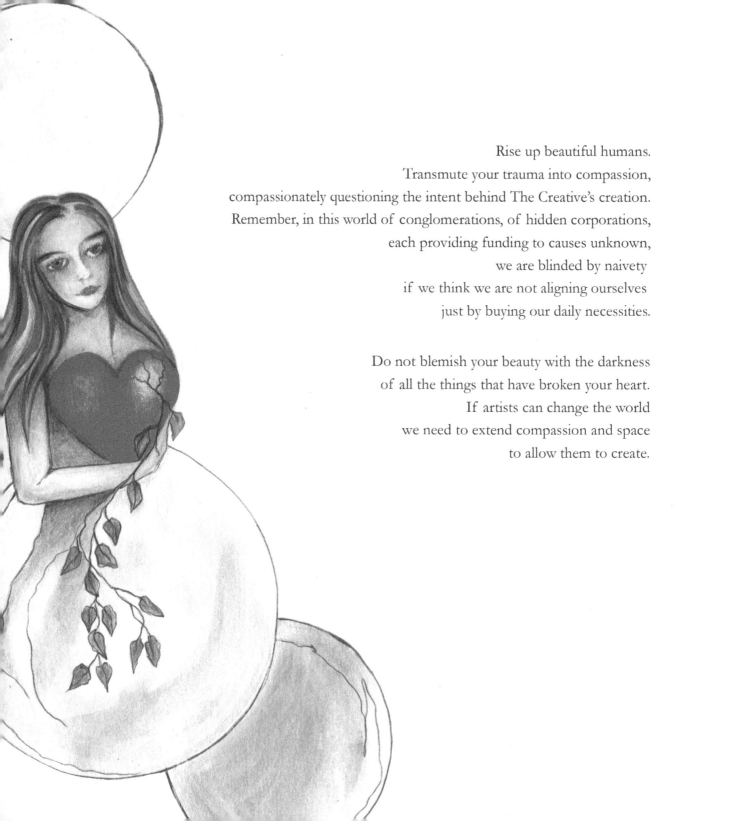

Rise up beautiful humans.
Transmute your trauma into compassion,
compassionately questioning the intent behind The Creative's creation.
Remember, in this world of conglomerations, of hidden corporations,
each providing funding to causes unknown,
we are blinded by naivety
if we think we are not aligning ourselves
just by buying our daily necessities.

Do not blemish your beauty with the darkness
of all the things that have broken your heart.
If artists can change the world
we need to extend compassion and space
to allow them to create.

INFINITY EDGE

Drop your proclivity

for preening, believing

unchangingly the things

you believe are unchanging,

And you will see, life has

AN INFINITY EDGE

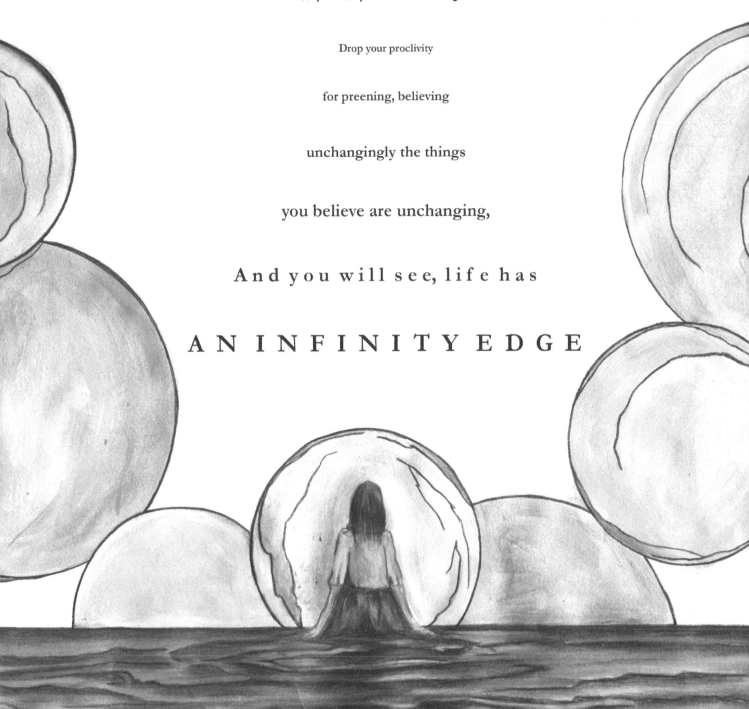

REFLECTION

REFLECTION

I see me reflected in your eyes and recognise

I am not the only one telling myself things

which seem comprised of lies

in an effort to modify core beliefs about me.

It will take more than just repeating

positive affirmations into a mirror reflecting

eyes back at me that do not see

any qualities of quality.

It will require a seismic shift to shift

the unshiftable layers of shit

fed to me by all and sundry,

limiting me to being nothing.

For now, I will believe what is reflected in a reflection,

can be changed with perspective

and retrospectively what was fed to me

was fed to me by those with perspective sullied

by generational experiences muddied

by intolerance.

For now, I will believe the change I am witnessing

as I witness more people listening,

agreeing intolerance is an intolerable perspective,

will trigger individual actions more reflective

of a world we can collectively live

with all experiencing what it is to be free and entitled

to the opportunity to be all we can be.

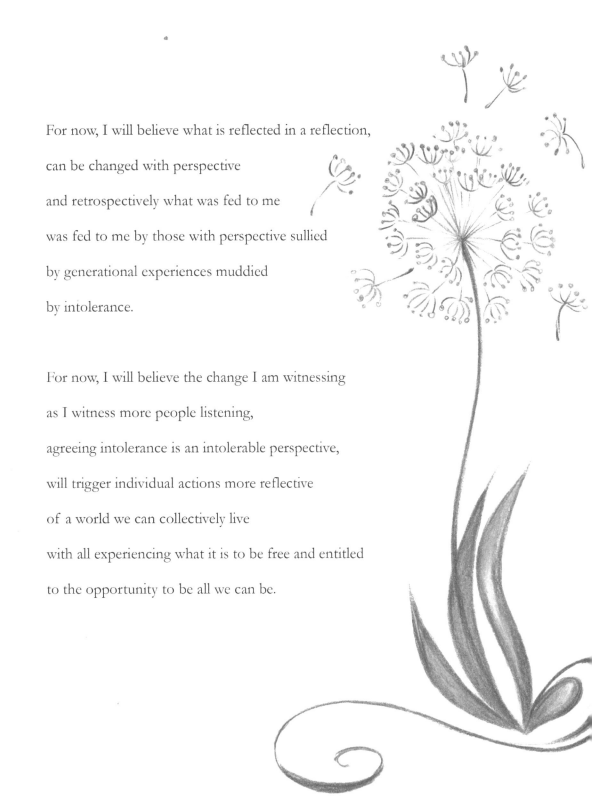

CHANGELINGS

We are perfection at the time of our birthing
up until the time we start imbibing
and learning beliefs
about the right and wrong of things.
We get used to doing our thing
all the while sensing something is missing
and then something comes along
that incites longing for a sense of belonging
and the changeling phase begins.
Incrementally we change a few things,
thinking no harm can be done,
making allowances for the ones we love
and soon, the perfect butterfly that was,
is not quite enough and the brilliance of
the colour of our wings starts to rub off.
Habitually adapting to our habitat, becomes a habit.
We accommodate what we think we must
to necessitate the continuance of belonging
to an ecosystem systematically dulling the colour of our wings.
So, we blend into a dull environment
which was never for us to begin with.

FUCK THAT SHIT!

Find the people you can be yourself with.

YOU ARE WORTH IT.

Strive to stand out not blend in.
because you are always that baby,

BORN PERFECT.

ELECTRIFY

Did you know, in Sweden,
Stockholm Central Station uses heat exchangers
to convert the body heat of commuters
into energy to heat water and pipe it
into an office building next door?

Did you know, according to my sources
informing on thermodynamic laws, that
energy can be neither created nor destroyed?
So, our innately existing electricity
is a conversion only,
of one form to another, of energy.
It cannot be created from nothing.
Meaning, while we are living and breathing
we are a source of renewable energy.
The definition of a perpetual motion battery.
Meaning, that without even consciously trying,
Humans, are electrifying.

ME

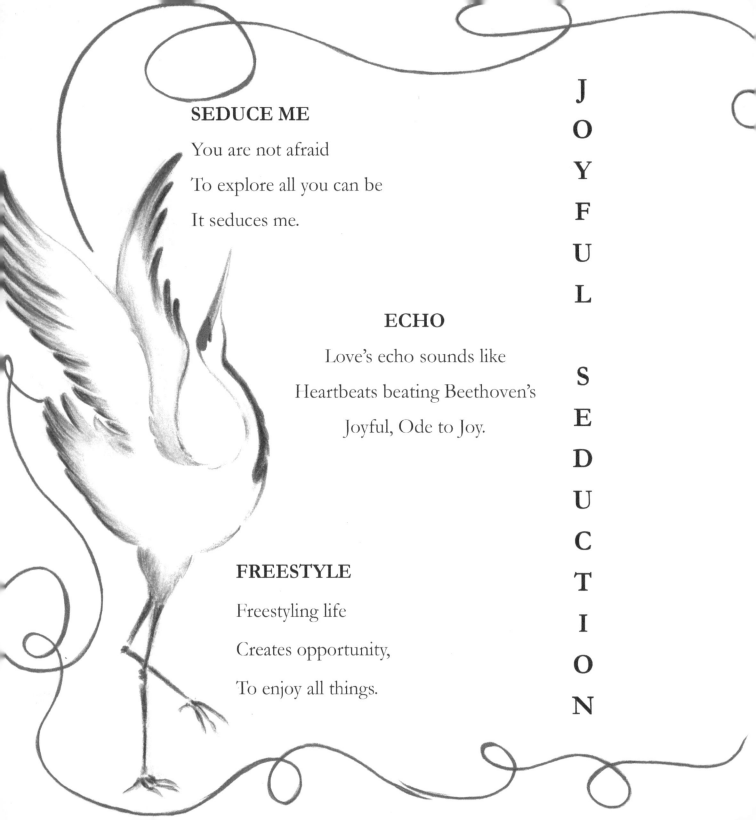

SEDUCE ME

You are not afraid

To explore all you can be

It seduces me.

ECHO

Love's echo sounds like

Heartbeats beating Beethoven's

Joyful, Ode to Joy.

FREESTYLE

Freestyling life

Creates opportunity,

To enjoy all things.

JOYFUL SEDUCTION

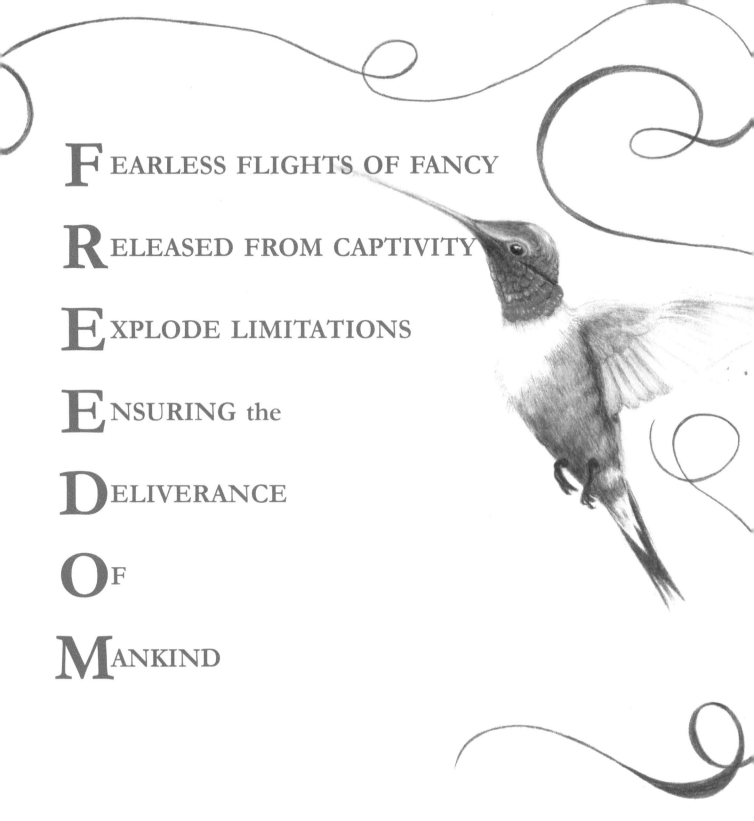

FEARLESS FLIGHTS OF FANCY

RELEASED FROM CAPTIVITY

EXPLODE LIMITATIONS

ENSURING the

DELIVERANCE

OF

MANKIND

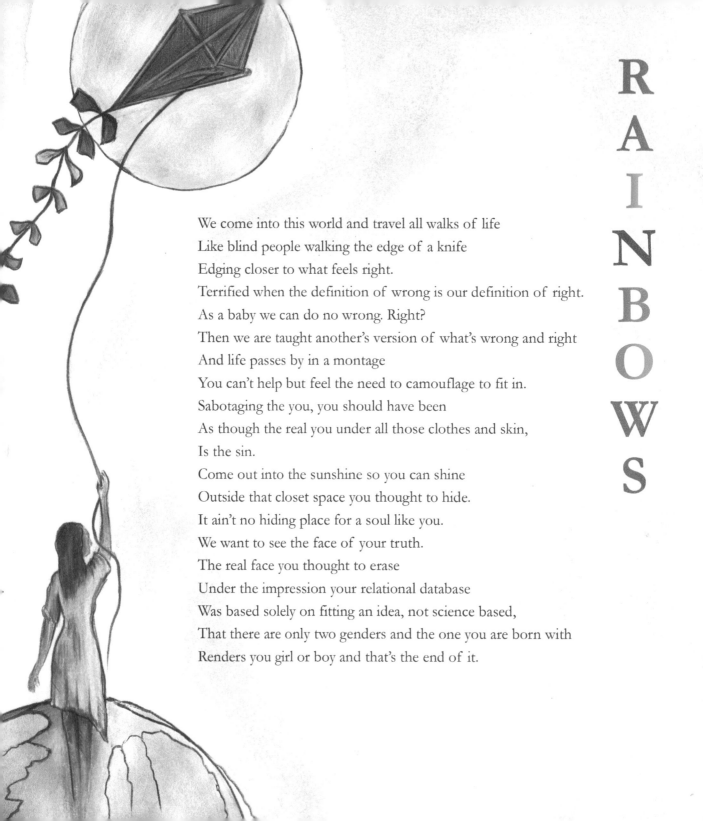

RAINBOWS

We come into this world and travel all walks of life
Like blind people walking the edge of a knife
Edging closer to what feels right.
Terrified when the definition of wrong is our definition of right.
As a baby we can do no wrong. Right?
Then we are taught another's version of what's wrong and right
And life passes by in a montage
You can't help but feel the need to camouflage to fit in.
Sabotaging the you, you should have been
As though the real you under all those clothes and skin,
Is the sin.
Come out into the sunshine so you can shine
Outside that closet space you thought to hide.
It ain't no hiding place for a soul like you.
We want to see the face of your truth.
The real face you thought to erase
Under the impression your relational database
Was based solely on fitting an idea, not science based,
That there are only two genders and the one you are born with
Renders you girl or boy and that's the end of it.

Step out into the light off the edge of that knife
You wish would splice all that's not you
Out of your life.
All you need to do is shine.
Be the you that lays sublime
Beneath a surface you have never been inclined
To mentally fall in line with.
No one needs a label or classification
To find freedom from subjugation.
Just step into the light, face the sun and
The shadow will fall behind you
Muting what's behind you
So we can see you;

The diamond, at the end of the rainbow.

E
N
D

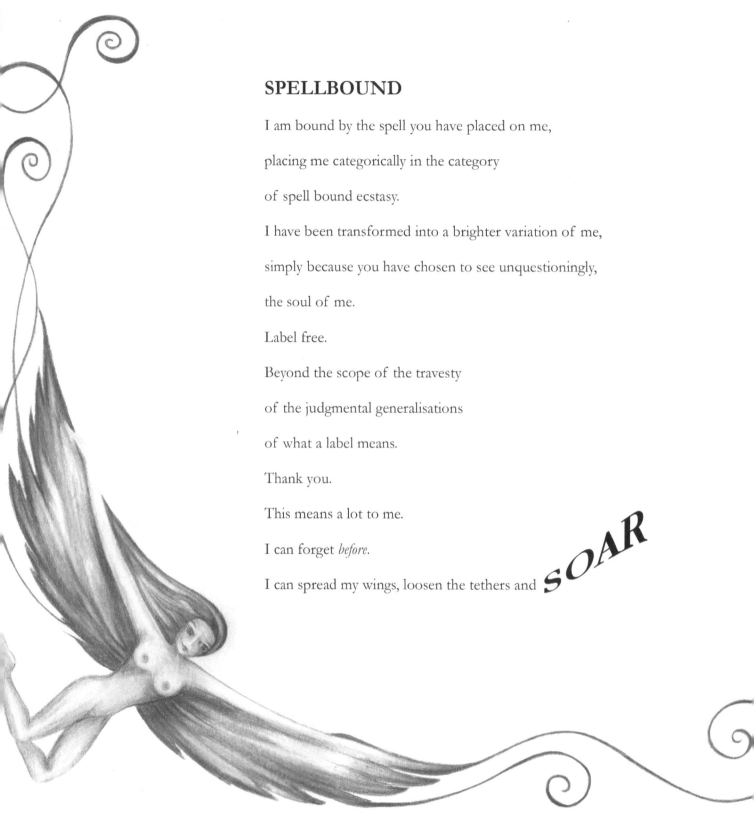

SPELLBOUND

I am bound by the spell you have placed on me,

placing me categorically in the category

of spell bound ecstasy.

I have been transformed into a brighter variation of me,

simply because you have chosen to see unquestioningly,

the soul of me.

Label free.

Beyond the scope of the travesty

of the judgmental generalisations

of what a label means.

Thank you.

This means a lot to me.

I can forget *before*.

I can spread my wings, loosen the tethers and *SOAR*

SUNLIGHT

You think I am the dark side of the moon

But I am only hidden from view

Because I choose to place my back to you

Keeping my orbit locked in a tidal lock

Because you continue to assume

Right and wrong is black and white

It is not.

But, you carry on spinning

Spinning a web with your thinking

That will keep you trapped and unthinking

About what you are missing by not seeing

I am bathed in sunlight and it is you

Occluded by shadow.

SHAPESHIFTER

I am ready to confess

I am the criminal who decriminalised

Fucking with my head

Giving the go ahead

To all and sundry to shun me

But I have made a discovery

Which will fast track my recovery

I am a Shape Shifter capable of shifting shape and

Changing my boundaries

I can grow wings and

Wing free of all the things

That have numbed me

I can change the shape of me

To break free from the box I put me

And allowed you to keep me

I am a Shape Shifter and I can dream

The shape and size of space I will occupy

So you can see me

It will be a criminal offence to contain me

You decided the form of me meant a certain thing

In the uniformity of how this world sees things

But I am going to break free of this skin

That does not fit me

And all you have to do is sit back

And enjoy the show

Because I am a Shape Shifter

And I am going to blow

SPLENDIFEROUS

It started out like any other day.
A repeating metaphor for,
Bleak outlook with a high chance of rain.
No trumpets or angels refrain to alert me
everything was about to change.

I'd spent a lifetime staying small
Not seeing a world where a space existed at all—
especially not for me.
In the event of rainfall, small surface area ensures
the probability of drowning is highly probable, and
no outer layer I created was impenetrable.

Every day has been a metaphor for death by drowning.
Then you came and,
in a single spectacular moment of acceptance
you showed me a space had always existed.
You showed me the space was full of infinite space
to be everything I had always been but hadn't seen.

I GREW.

An immediate precipitous blossoming,

blossoming with surefooted confidence.

You at my back. An impenetrable shelter,

sheltering me from any storm

that would have previously drowned me.

Drowning has ceased being a worry.

Although we are made to believe

we are in control of what we believe about ourselves,

germination from seed to sensational being,

needs a showering of reassurance

that it is our birthright to fill space and be.

Intertwining it with the sunshine of sublime acceptance,

given unconditionally,

allows each of us our space to shine,

SPLENDIFEROUSLY.

THE OTHER CHEEK

Turn the other cheek. What you sew you shall reap.

These are some things organised religion likes to teach.

Brainwashing the mind of a child before the child can see

These two instructions have no place in instructing

How to live life without self-destructing.

I mean really, for every time that I turned the other cheek

I learned I was not allowed to set boundaries around how others would treat me.

I learned to diminish me.

Yet somewhere in that book of God, I remember there was another verse

That told us not to hide our light under a bushell,

For that was a sin also.

Confusing messages for a child, no?

The lesson was submerged so deep

I moved through life turning that cheek

And it was slapped in a quickstep dance on repeat.

The seeds I sewed I certainly did reap.

My actions did not teach those around me

The beauty of forgiving,

Only that they could enable my obsession

Of dancing with Diminishing

And what a partner he turned turn out to be.

It's going to be an effort to let go of the beliefs

That turned my life into a shit show,

But I have come to see, you get to choose what you believe

And none of it has to contain a single seed of what was taught to me.

Most of those seeds were weeds set to grow prolifically and do nothing,

But stop me from creating and manifesting the life I deserve to live.

So, Fuck you! Fuck you! And fuck you, also,

You nonsensical, unhelpful deep-seated beliefs.

You have no place inside of me.

Pack up your bags, collect up your seeds

And get the fuck out 'cause now I choose to believe

I can manifest success consistently.

Best of all, I don't have to turn the other cheek

Allowing indecent fucks to hold power over me.

I do not contain the light—

I *am* the light!

Off you go.

I don't need to see you out

You are worth not one more second of my time, so waste no time

Getting the fuck out!

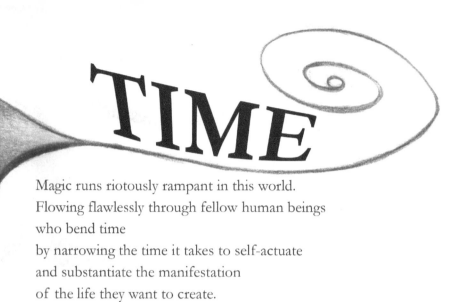

TIME

Magic runs riotously rampant in this world.
Flowing flawlessly through fellow human beings
who bend time
by narrowing the time it takes to self-actuate
and substantiate the manifestation
of the life they want to create.

These prodigious people
purposely perpeptuate the evidence-based phenomenon
of how fast things can happen when you focus on
doing what brings you joy.

They understand, the focus required
to live the life they desire, can only be inspired
by doing what inspires them.
Not just doing any old thing
to pay the rent and put away enough
so one day they can do the thing they love.

You can feel the thrum of these people that hum
with the vibration of the incarnation of
what they have set their focus on.
And, it may seem that with seemingly small struggle
sensational success streams in excess towards them.
But do not mistake the ease with which they demonstrate
how easy it is to appropriate
the things they want and then some, for dumb luck.

BENDERS

They know a secret we are not all privy to, but we have access to.
Time bending manifesting comes from investing
time into dreaming then welcoming in
all the things that feed the dream.
It requires strength and determination to stick with that thing
despite the naysayers, voicing from their state of deep sleep,
their unsought opinion
to give in.

Remember the wisdom of the ancients.
Exit the mainstream and slip into the slipstream
of wakeful awareness
We are all time benders.
Manifesters.
Capable of anything we choose to set our hearts to.

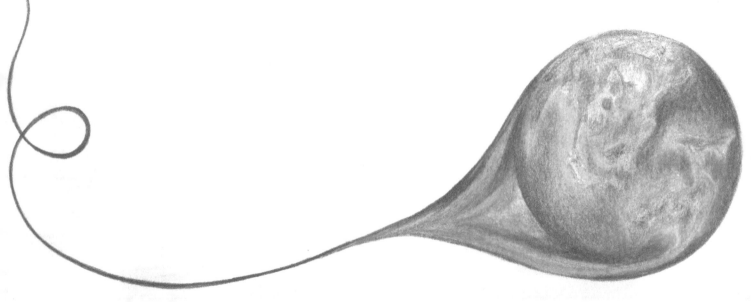

D I S C O V E R Y

I was taught, *If you fail to plan, you plan to fail.*
I have discovered,
somehow dreams unfold in ways beyond our control
when we venture off plan into the unknowable.

I was taught, life is in a permanent state of change.
Yet we seem determined to resist it.
Steadfastly miserable about the *new normal,*
despite the isolating and distancing having created space for listening.
Space, for finding solutions
to mending all the pieces we are learning are broken.
I have discovered, change recalibrates my orbit towards
the gravitational pull of experiences I've never dreamt of.

I was taught a doctrine about the Right and Wrong
of a plethora of things
which created a bedrock of opinions based on inherited beliefs,
but no experiential knowing.
I have discovered, opinions are better fluid,
nothing beats experience
and Right and Wrong are just perspective.

I was taught that love, anointed by God,
adhered to strict rules on race, religion and gender.
I have discovered, there is so much more to love
than any of these things
and it cannot in stone be rendered
as commandments.

I have fallen in love with women who are strong beyond
any notion of the notion of strength I was born with.
Articulating truths of the collective from personal perspective
they embody the spirit of Amazons
and I have discovered, I cannot help but love them.

I have fallen in love with men of all race, religion and sexual orientation.
Watching them stand in solidarity with women and other minorities,
I have discovered all the beautiful a man can choose to be
and there is no denying, this has changed me.

I have fallen in love with humans who do not identify
as one gender or another and they exemplify courage.
They are fearless because they have faced the worst of us
yet choose to stand up and be counted.
Honouring their truth even when rigid minds refuse
to acknowledge the scientific basis of their truth.
There is splendour and magnificence in what makes us all different
and I have discovered I can no longer be, indifferent.

I have fallen in love with individuals
classified, minimised and victimised throughout the ages.
Things I was taught I should not tolerate
I now appreciate and celebrate.
I have fallen in love with people in general
and I have discovered it does not need to be sexual
to be deeply effectual on my soul.

Everyone I have fallen for, first and foremost, is a person
and I have discovered that by embracing all that is human,
instead of the rules trying to contain all that is human,
more possibilities exist for whom we can fall in love with
than what is suggested by a poorly informed idea
of the right or wrong of whom we can fall in love with.

During this unique time in human history
I have taken a journey of discovery
And recovered the innocence of a mind emptied of ignorance.
I've had my eyes opened to the instability
Of inherited beliefs that no longer serve
If I am to practice being human decently.
I have realised I know nothing
And I have discovered, there are infinite truths and realities
Waiting to be embraced by minds that are free.

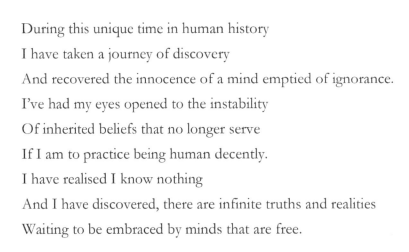

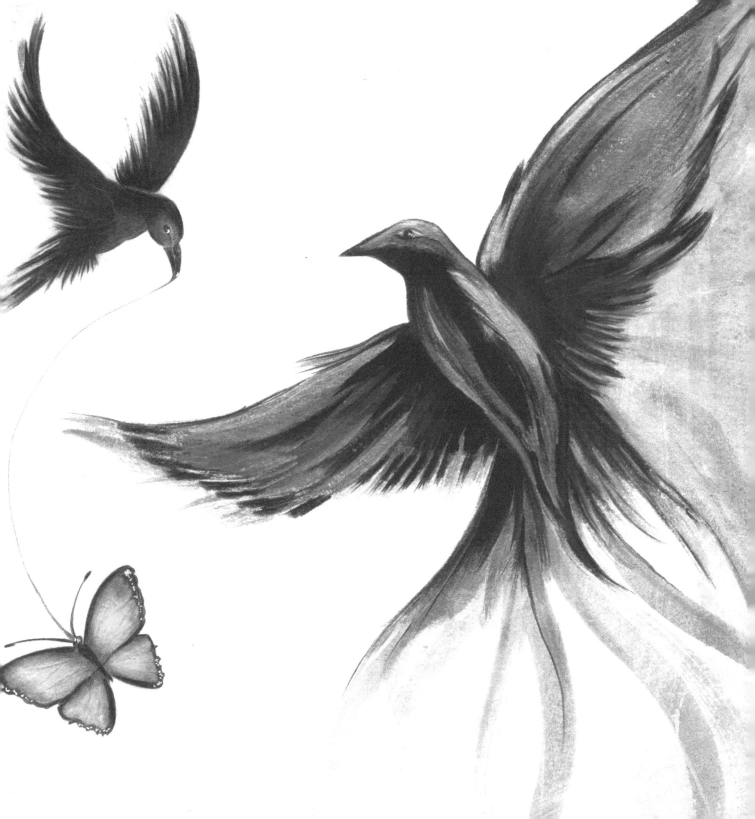

AUTHOR NOTE

I am prone to dark days, grandiose misgivings, bone numbing loneliness, ridonculous bouts of silliness, highs, lows and everything in-between i.e., I am prone to being human. Aren't we all?

When my first book, Pieces of Humanity, was published in 2020, the global pandemic of COVID-19 had us taking book launches online and I was both astounded and humbled by the number of humans from all over the world who made the time to attend, especially considering I was a newbie to the online poetry circuit, but what followed on has without a doubt, caused a seismic shift at my core.

It is often said that adversity is the mother of invention, and it is no small proclamation. Without COVID-19 I would never have found myself jumping time zones to attend events, would never have had the opportunity to meet, collaborate, perform alongside of and befriend so many sensational human beings and would never have been granted such a well-rounded education on what it is to be human.

Engaging with such a diverse group of people, all facing challenges unique to themselves, all with their own perspectives and opinions and lived experiences, opened my mind to the many other 'realities' that exist outside of my own. Every poem in this book flowed from that place. It is a celebration of all that is human and a call to all humans to crack themselves open, let go of assumption and the ego, be brave, decent, and embrace their right to shine.

So many individuals have been generous with their patience and willingness to educate me where I needed it and when I asked. It was not lost on me that for some of you, having to explain concepts I had never considered or had the opportunity to explore, was not necessarily a fun exercise, yet you did it anyway. Rikki Livermore, you are without a doubt one of the most generous humans I know and a born educator. There would be far less fuckery going on in this world if there were more of you, but at the same time, one Rikki is enough and I love you for all that you do and all that you are. Thank you.

Thank you to the event hosts whose provision of safe spaces for creatives to gather and share has been a great service to humanity in this time of isolation. Pic n Mix and Say It Louder – Gary Huskisson, Fin Hall – Like a Blot From The Blue, Shruti Shukla – Itch It Out, Christine Hall – Poetry In The Brew, Kathleen Strafford – Runcible Spoon, Rikki Livermore – Poetry At Your Place, Michael Wilson - Lit Up, Marissa Prada – Word Is Write, Fiona Hooper – The Poetry of Painting, Lauri Schoenfeld – The Inner Enlightenment Show, West Side Poetry, Run Your Tongue, Fire and Dust, Poetica, Spoke and Bird, Write and Release, Mother Tongue, Ad Lib's Got Talent, Pint of Poetry, Away with Words, To The Ends of The Interwebs, Enough Said, , Time to Arrive, and so many more. Clive and Nick – Oooh Beehive, thank you for your patience and for keeping faith in me at a time when I had lost all faith in myself. It meant the world.

Thank you to all the wonders who hold space for me no matter where I am at. Mel, Gary, Cathy, Susan, Lauri, Christian, Special K, Paul, Rikki, my tribe - Sarah, Jen, Kim, Janine, Jodie, Leanne, Neshka, the Perth Slam community, and most certainly a pageful more.

Neshka, you are a wonder. I dreamt of creating a book of beauty that could speak through words and art and you hit the go button and never looked back. Look what you did girl! I love you. Thank you.

Lisa, the winged creator of Dragonfly Publishing, thank you for giving my second book a home and, 'getting it'.

And finally, to all who take the time to appreciate these pages: live decently, be all the beautiful you can be and ALWAYS, ALWAYS, SHINE.

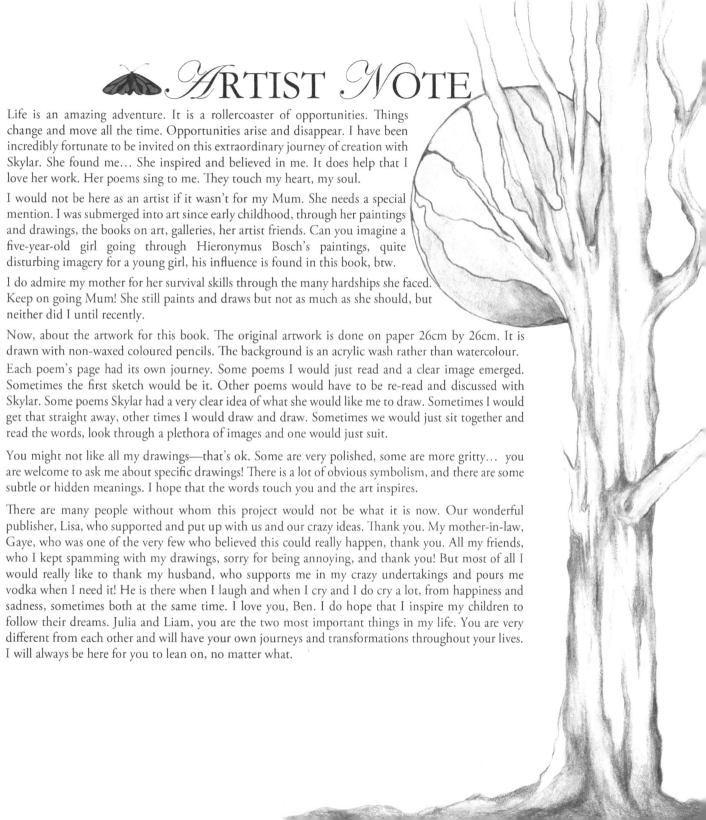

ARTIST NOTE

Life is an amazing adventure. It is a rollercoaster of opportunities. Things change and move all the time. Opportunities arise and disappear. I have been incredibly fortunate to be invited on this extraordinary journey of creation with Skylar. She found me… She inspired and believed in me. It does help that I love her work. Her poems sing to me. They touch my heart, my soul.

I would not be here as an artist if it wasn't for my Mum. She needs a special mention. I was submerged into art since early childhood, through her paintings and drawings, the books on art, galleries, her artist friends. Can you imagine a five-year-old girl going through Hieronymus Bosch's paintings, quite disturbing imagery for a young girl, his influence is found in this book, btw.

I do admire my mother for her survival skills through the many hardships she faced. Keep on going Mum! She still paints and draws but not as much as she should, but neither did I until recently.

Now, about the artwork for this book. The original artwork is done on paper 26cm by 26cm. It is drawn with non-waxed coloured pencils. The background is an acrylic wash rather than watercolour.

Each poem's page had its own journey. Some poems I would just read and a clear image emerged. Sometimes the first sketch would be it. Other poems would have to be re-read and discussed with Skylar. Some poems Skylar had a very clear idea of what she would like me to draw. Sometimes I would get that straight away, other times I would draw and draw. Sometimes we would just sit together and read the words, look through a plethora of images and one would just suit.

You might not like all my drawings—that's ok. Some are very polished, some are more gritty… you are welcome to ask me about specific drawings! There is a lot of obvious symbolism, and there are some subtle or hidden meanings. I hope that the words touch you and the art inspires.

There are many people without whom this project would not be what it is now. Our wonderful publisher, Lisa, who supported and put up with us and our crazy ideas. Thank you. My mother-in-law, Gaye, who was one of the very few who believed this could really happen, thank you. All my friends, who I kept spamming with my drawings, sorry for being annoying, and thank you! But most of all I would really like to thank my husband, who supports me in my crazy undertakings and pours me vodka when I need it! He is there when I laugh and when I cry and I do cry a lot, from happiness and sadness, sometimes both at the same time. I love you, Ben. I do hope that I inspire my children to follow their dreams. Julia and Liam, you are the two most important things in my life. You are very different from each other and will have your own journeys and transformations throughout your lives. I will always be here for you to lean on, no matter what.

AUTHOR BIO

Skylar J Wynter is the best-selling author of poetry and flash fiction collection, *Pieces of Humanity* released on October 10th, 2020 to align with National Mental Health month.

After an incident which changed the course of her life in 2014, Wynter turned to various artforms to process the trauma and make sense of her new self. She shares her poetry in the hopes it will help others find peace within their own realities and encourage humanity to reach out to each other with decency.

Skylar resides in the Perth Hills of Western Australia, where she pens her creations overlooking national parkland, and when she is not writing, she likes to create beautiful things with her limited jewellery-making and sculpting skills, and serene spaces in her garden. She loves a great book, a sunny day and witnessing humans behaving decently. She hates cooking and injustice, hopes COVID-19 disappears and online poetry events don't, and someone finds a way to make celery taste like cheesecake.

For details of Skylar's poetry and authorship, please visit: https://www.skylarjwynter.com

ARTIST BIO

Neshka Turner is an emerging Australian artist living in sunny Perth, Western Australia. She was born in Poland as Agnieszka Beata Chechlowska in the early 70s, from where she was ripped away and moved to Germany and then Australia. She changed her first name so you can pronounce it easier, and got an easy surname by marriage.

She has studied art under her mother's—also an artist—guidance since early childhood. Not that her mother ever wanted her to be an artist; you hardly ever succeed and don't make money. Neshka graduated from Newtown High School of the Performing Arts and went on to study Visual Art at the Sydney College of the Arts in the 90s. However, her career has taken her on a different path before rediscovering creativity again in the 2020s.

She has worked in retail, Internet and Information Technology areas, training, HR, Vocational Education, and lately, working with special needs children as an Educational Assistant.

Now she illustrates poems and more. She works in most media, including pencil and coloured pencil, charcoal, hard, soft and oil pastels, acrylic and oils. Her subjects are all and many. You can view and purchase her art through her website, and watch this space as she will be entering into art competitions in the next few years to establish her name.

Neshka's art can be viewed and purchased at: https://www.artbyneshka.com

Spoken Words

Scan the QR codes to hear Skylar perform the poem:

Part One - Don't Tell Me To Breathe

 Part One - Algebra Lesson

Part Two - Seems Odd To Me

 Part Two - The Phone Call

Part Three - Rainbow's End

 Part Three - Discovery

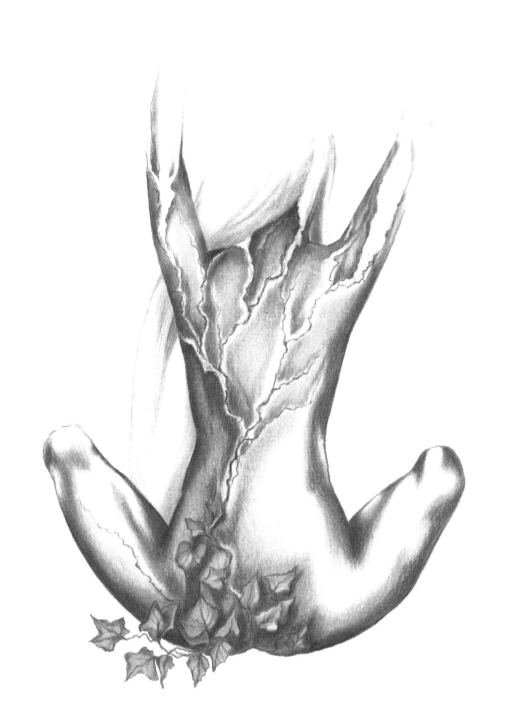